TIBET

Caught in Time

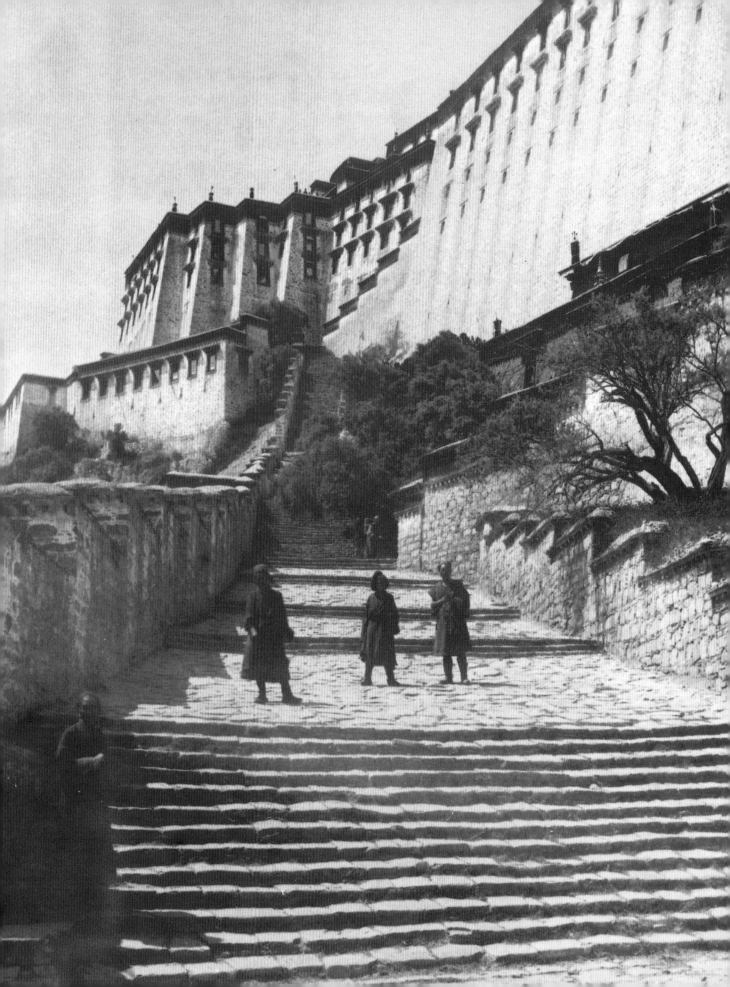

TIBET

Caught in Time

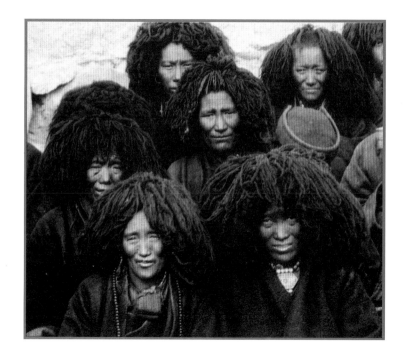

John Clarke

Foreword by the Dalai Lama

in association with
THE BRITISH LIBRARY

Garnet
PUBLISHING

Tibet: Caught in Time

Published by
Garnet Publishing Limited,
8 Southern Court, South Street,
Reading RGI 4QS, UK

First edition 1997

ISBN 1 873938 96 9

British Library Cataloguing-in-Publication Data
A catalogue record for this book is available from The British Library

Copy-editor: **Michael Burbidge**
House editor: **Anna Watson**
Production: **Nick Holroyd**
Design: **David Rose**
Additional design: **Michael Hinks**
Map of Tibet on page vii drawn by Geoprojects (UK) Ltd., © 1997

Printed in the Lebanon

Opposite previous page
*1. The broad stone steps up to the front of the Potala Palace. In the summer, when the wells in
Lhasa dried up, women and children would carry water in pots from the river – an hour away –
for the 175 monks living in the Potala. The task was a form of tax, but this did not stop the
carriers singing as they wound their way to the top of these steps.*
John Claude White

Previous page
2. Tibetan nuns at Tatsang on the Sikkimese–Tibetan border (detail of figure 109).
John Claude White

Contents

Glossary

Amban The representative of the Chinese Imperial Government stationed in Lhasa between 1727 and 1913.

Bodhisattva A spiritually evolved person who chooses to be reborn to guide others towards Enlightenment.

Bon A Tibetan religion that is mainly a blend of Buddhism and older animistic beliefs.

Buddha Sakyamuni The founder of Buddhism, a religious teacher who lived and taught in northern India from 563 to 483 BCE.

Chorten A conical structure which symbolizes the Buddha's Enlightenment and the Enlightened mind.

Drilbu The Tibetan term for bell (Sanskrit *ghanta*), ritually representing the ultimate understanding of reality, the highest wisdom.

Dzong A fortress, usually the residence of a district governor (Dzongpon).

Dzogchen Teachings and meditational practices found in the Bon religion and the Nyingma and Kagyu schools of Buddhism that emphasize a direct approach to our innate Buddha nature.

Gelong A fully ordained monk.

Geluk An order of Tibetan Buddhism founded in the early fifteenth century by Tsongkhapa. Also known as the 'Yellow Hats' or 'Virtuous' order.

Geshe The highest formal degree given in the Geluk order, equivalent to Doctor of Theology in the west.

Geshul The probationary grade of monkhood prior to becoming a Gelong.

Jokhang The main temple of Lhasa, built in the seventh century to house the Jobo ('Precious One'), an image of the Buddha Sakyamuni brought from China by Wen Cheng, the Chinese wife of Songtsen Gampo.

Kagyu An order of Tibetan Buddhism founded in the eleventh century by Gampopa and his followers, and counting in its lineage the saints Marpa and Milarepa.

Kangyur The collection of teachings in the Tibetan canon attributed to the Buddha Shakyamuni.

Lama An honorific term for a particularly revered religious teacher, not necessarily a monk. The term is, however, also used almost synonymously with that for a monk.

Mandala A ritual diagram depicting a consecrated space, visualized as the abode of an Enlightened being.

Nyingma The 'old' order of Tibetan Buddhism with origins lying in the seventh to eighth centuries when Buddhism was first introduced into Tibet.

Sakya A Tibetan religious order founded in the late eleventh century and named after its place of origin in southern Tibet.

Thangka A religious scroll painting.

Tantra Scriptures and practices describing a fast approach to Enlightenment through the visualization of deities and mandalas, the recitation of mantras and the re-direction of inner energies.

Tengyur The second section of the Tibetan canon, containing the Indian commentaries on Buddha's teachings.

Vajra (Tibetan *dorje*) 'Diamond Sceptre' or 'Thunderbolt'; a ritual object representing (singly) Enlightenment or the Buddha state and (paired with the bell) the compassionate activity of Enlightenment.

Vajrayana 'The Diamond Vehicle', employing tantric practices to reach Enlightenment; teachings that developed out of Mahayana Buddhism in India between the fourth and eleventh centuries.

MAP OF TIBET

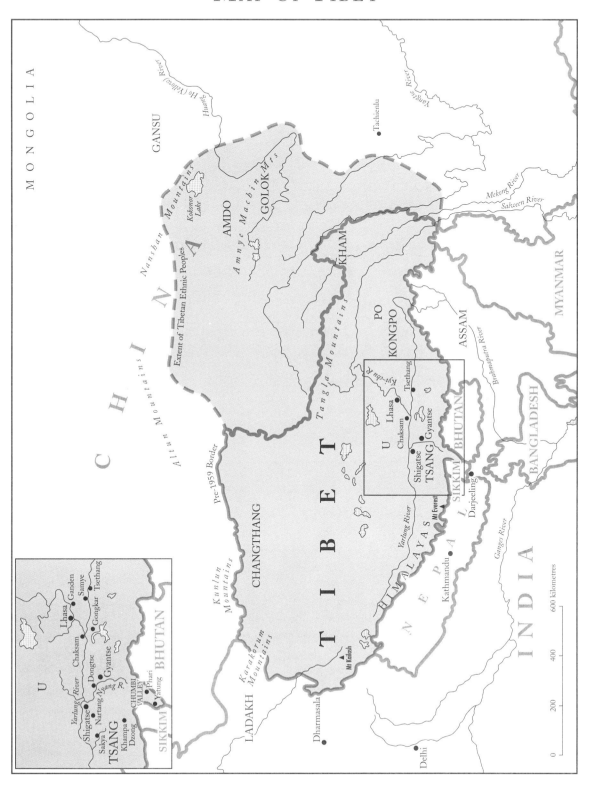

Note on Tibetan Names

Tibetan names in this book have been given in their phonetic forms to make comprehension easier for those not familiar with the language. Though the language is syllabic, and often hyphenated when written in roman form, syllables have been combined and hyphens omitted here. The written language also contains many unpronounced prefixes, for example dGe-lugs-pa (pronounced Gelukpa), and unpronounced suffixes, for example 'Bras-spungs (pronounced Drepung). There are other combinations of consonants which form new consonantal sounds, such as bKra-shis-lhun-po (pronounced Tashilhunpo). All of these have been given in their phonetic versions.

Acknowledgements

I am especially grateful to Zara Fleming who has given unstinting help during the writing of this book. I would also like to thank Dr Alex McKay, Patrick French, Tsering Shakya, Geshe Thubten Jinpa and Barbara Tyrell for their assistance with various questions and with proof-reading.

THE DALAI LAMA

Foreword

Looking at old photographs of Tibet evokes a mixture of pleasant and sad memories. Especially for me, and many Tibetans it is all the more poignant because we have been unable to return to our homeland since 1959.

Since the Communist Chinese invasion in 1949/50, the peace-loving people of Tibet have undergone unimaginable suffering and over 6,000 monasteries – repositories of our cultural heritage – have been destroyed. Even the fragile ecosystem has been threatened by the influx of Chinese immigrants. Yet, during this tragic period the Tibetans inside Tibet have not lost their spirit and those of us in exile have been able to preserve our distinct culture and national identity. To a large extent this has been possible because of the concern and support that the Tibetan people have been receiving from the international community.

I hope that readers of this book will see the richness of Tibetan culture, which Charles Bell and John Claude White so carefully recorded in the early decades of this century. While some of you may have seen examples of our *thangka* (scroll) paintings or carpet weaving, or may have learnt about Tibetan Buddhism, these pictures show many aspects of our country, and particularly the daily life of people when Tibet was free.

While looking at these photographs, it should be remembered that the Tibetans inside Tibet continue to suffer on a daily basis under the Chinese repression and that the Tibetan Buddhist culture is facing the threat of extinction. The photographs in this book especially give detailed insights into our history and a sense of a culture which has survived since ancient times. I hope you will do whatever you can to support the just cause of Tibet and the Tibetan culture which I believe has the potential to benefit humanity.

Dharamsala, 1997

Introduction

As we approach the end of the twentieth century, Tibet continues to exercise a hypnotic grip on the western imagination. The reasons for Tibet's unparalleled ability to epitomize remoteness, spirituality and mystery lie both in geographical circumstance and historical fact. It has always been difficult to penetrate the barriers of barren plateaux, high-altitude deserts and the

tallest mountains in the world. More significant still is the fact that from the late eighteenth century onwards Tibet pursued a deliberate policy of excluding foreigners. These factors meant that Tibet preserved, until the mid-twentieth century, an extraordinary Buddhist culture very little affected by western technology or thought. It has been described as the last great literate civilization

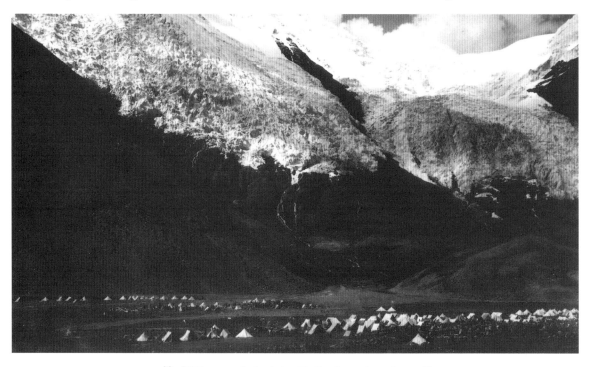

3. The British camp under the glacier at the Karo La pass (around 17,000 ft)
during the 1903–4 expedition's advance on Lhasa (see p. 8).
John Claude White

to come down to us as a living entity from the distant past, not glimpsed as in the case of ancient Egypt through texts or ruins, nor seen through layers of accretion as in the cases of India and China. Tibet closed its borders in the late-eighteenth century, at about the time that the Industrial Revolution was gathering pace in England. Tibetans feared for their culture and above all their religion as British power edged ever nearer. Their view of Britain as a dangerous expansionist power was encouraged by their Chinese overlords, who wished to keep Tibet as a buffer zone free of western influence. The result was a strict policy of excluding foreigners, with harsh punishments, including death, being carried out on those found guilty of helping them enter.

Tibet became synonymous with the mysterious and inaccessible as a succession of western explorers attempted to penetrate its isolation in the nineteenth century. These attempts usually ended in failure with explorers turned back by Tibetan troops, often after having endured incredible hardships on the high plateau. Tibet's mystique became a blend of differing focuses of western curiosity. For some it was a land of adventure and danger where explorers might discover the sources of the great rivers of Asia, while others found a backward and cruel feudal people practising a degenerate form of Buddhism. Still more were enchanted by the depth of its spiritual culture. For them it became a country of shining faith and spirituality where the deepest secrets of the universe were to be learned. Like medieval Europe, Tibet contained such extremes of wealth

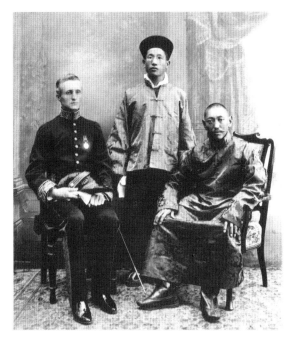

4. The Thirteenth Dalai Lama (right) and Charles Bell (left) seated in a formal group with Sidekong Tulku, the King of Sikkim, standing behind them. While the British had made Sikkim a protectorate in 1888, it still retained the then king, Sidekong Tulku's father. The intelligent and strong-willed Sidekong Tulku died in 1914, under suspicious circumstances according to Sikkimese sources. Taken in Calcutta in 1910 during the Dalai Lama's exile following the Chinese invasion of Tibet. P. A. Johnson and T. J. Hoffmann

and opposites of behaviour as to make all of these viewpoints at least partially true. But such diverse conceptions of Tibet are ultimately misleading because of their unintegrated and uncontextual nature. Independent Tibet never opened its borders to western visitors as Nepal was to do. Only a few privileged westerners, mostly diplomats, experienced the culture through living in it rather than as explorers travelling through it. These included the small cadre of British frontier officers, posted as Trade Agents inside Tibet or as Political Officers in nearby Sikkim, who were permitted to enter parts of the country. It was three of

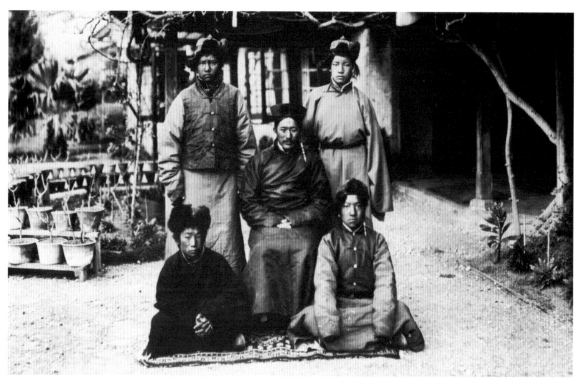

5. The four Tibetan boys sent to school in England in 1913 as part of the Dalai Lama's attempt to modernize Tibet. They sit at each side of their guardian, Lungshar. They were enrolled at Rugby, one of the best public schools. Ringang (bottom right, see also figure 42) was the brightest, studying foreign languages and coming top of his class at mathematics. After leaving Rugby he studied electrical engineering and on his return installed electricity in the Norbulingka Palace and in Lhasa. Gongkar (top right) chose a career in the military but unfortunately died soon after his return to Tibet in 1918. After unsuccessful attempts to study geography, cartography and irrigation, Kyipu (bottom left, see also figure 133) was put in charge of developing the telegraph system in Tibet, but he failed at that too. Mundo (top left) was originally a monk. He developed an interest in geology and was enrolled in the Camborne School of Mining in Cornwall. Returning to Lhasa he carried out fieldwork, but his attempts at mineral prospecting met with the usual opposition from lamas, worried that the spirits of the soil would be disturbed. An incident where a high official was thrown from his mule as the result of being frightened by Mundo on his Indian motorcycle resulted in a posting to a remote area for several years. In the final analysis the boys had little impact on Tibetan history, remaining as they did on the periphery of power. Unfortunately, being only members of the minor nobility, they carried little influence.
Charles Bell

these men, Charles Bell, John Claude White and David Macdonald, who took most of the photographs in this book.

The earliest of the photographs were taken by John Claude White in 1903–4 when accompanying Colonel Francis Younghusband on his military expedition to Lhasa. The post of Political Officer in Sikkim was established in 1889 and White became its first holder. The Political Officer was a spy-cum-ambassador, who kept in touch with the changing political scene, gathered information and promoted the Raj's interests in Sikkim, Bhutan and Tibet.

Bell (see figure 4), who held the same post from 1908 to 1918, was the classic figure of the scholar–administrator. Early on in his career he

was stationed in Darjeeling and quickly developed a strong interest in the language and culture of Tibet, publishing a Tibetan grammar and dictionary. Bell had a deep empathy with Tibetan culture and developed close friendships with the Thirteenth Dalai Lama and members of the governing aristocracy. But at the same time he was a shrewd political operator fully attuned to the workings of both the British and Tibetan governments. To him, the security of the Raj always came first. At the start of Bell's tenure of office as Political Officer, Tibet had undergone a major political upheaval. The Chinese had invaded central Tibet and occupied Lhasa in 1910, causing the Dalai Lama to flee to India. It was during his three years in exile that Bell deliberately befriended him, laying the foundation of a relationship that would have far-reaching benefits for the British position in the Himalayas. After the Dalai Lama's return, the British promoted a strong and independent Tibet as a buffer for India, one that could hold its own militarily against China but in which British influence would remain paramount. Bell realized that the Dalai Lama was the one person who stood any chance of pushing through reforms that could strengthen Tibet. Consequently, he gave the strongest encouragement to the Dalai Lama's programme of modernization begun after his return in 1913, clearly shaping the Tibetan leader's thinking on key issues such as reform of the army and education. As a result, in 1913, four boys were sent to England to be educated (see figure 5). Later, in 1923, an English school was opened at Gyantse.

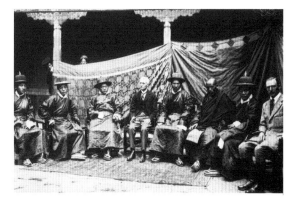

6. Charles Bell and high officials seated at the folk opera (Ache Lhamo) which Bell hosted during his mission to Lhasa in 1921. Left to right: Dorje Techi; the Duke (Kung) of Chang-lo-chen; Tsarong Shapé (Cabinet minister); Charles Bell; Ngarpo Shapé (Cabinet minister); Parkang (priest Cabinet minister); the Duke (Kung) of Punkang; and Lieutenant Colonel R. S. Kennedy of the Indian Medical Service. Tsarong Shapé was famous for his heroic defence of the Thirteenth Dalai Lama as he fled to India in 1910; with a small group of Tibetan soldiers he held off 200 Chinese soldiers at the Chaksam ferry.
From Bell's archive, photographer unknown.

British officers like Bell had experience of the Tibetan borders and southern Tibet but not of Lhasa, the capital. This was because, under the terms of earlier treaties, British Political Officers and Trade Agents were only permitted limited access to Tibetan territory, as far as Gyantse; Lhasa required special permission. But in 1920 Bell finally got his chance to visit the capital when the British government appointed him to head a 'mission' to Lhasa. This mission, devised as a way of both offsetting the success of a recent Chinese visit and increasing British influence in Tibet, proved decisive in opening Lhasa to British diplomatic contact and at least one representative visited the capital each year thereafter. It also paved the way for the establishment of a permanent British mission in Lhasa in 1937 (which lasted until Indian independence in 1947). A high

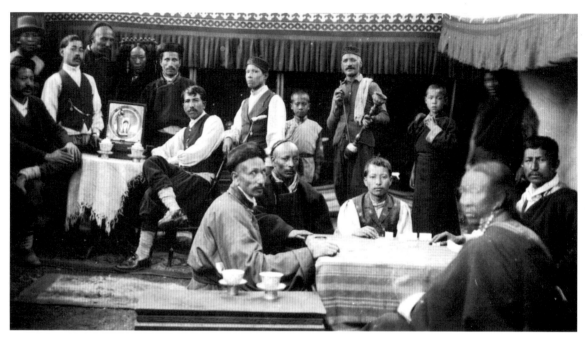

percentage of the photographs reproduced here were taken during the eleven months that the mission was in Lhasa. In *The People of Tibet*, Bell mentions that one of his Sikkimese orderlies, Rabden Lepcha, increasingly took over his photographic work during the mission. A later trip was made by Bell in 1933 to gather more information for his books.

Bell went further than any other British official of his time in accommodating Tibetan culture. He spoke fluent Tibetan, adhered to Tibetan customs and showed due respect for Buddhism. Many officials in Lhasa trusted and respected him. One wrote to the Dalai Lama: 'When a European is with us Tibetans I feel that he is a European and we are Tibetans; but when Lonchen [Great Minister] Bell is with us, I feel that we are all Tibetans together.' Some Tibetans

7. A group of Nepalese on a picnic near Lhasa. To the right, several play *ba*, a Chinese game for which dominoes and dice are used and which is a great favourite at picnics. Note the western dress and gramophone on the left. From an early period the Nepalese, particularly the Newars of the Kathmandu Valley, had been important in Tibet as metalworkers and traders. By 1950 there may have been six to seven hundred Newars in Lhasa and up to a thousand of mixed Newar–Tibetan parentage (*katsara*). The Barkhor with its market was one of their main areas for trading and many of the shops there were owned by them.
Charles Bell

explained his empathy for their culture by claiming that he was the reincarnation of a high-ranking Tibetan who had prayed to be reborn in a more powerful country in order to benefit Tibet. Although Bell always retained his British identity and Christian beliefs, his deep knowledge of Tibetan culture and language enhanced his considerable diplomatic skills. This gave him an intuitive grasp of the situation in Tibet, a quality commented on by his peers. He turned to scholarship on his retirement in 1918 and began writing

the four major works which are still significant sources for students of Tibetan culture.

Other photographs were taken slightly earlier by David Macdonald, whom Bell chose to fill the post of Trade Agent in Yatung in 1909. Although Trade Agents were subordinate to Political Officers they in fact carried out similar functions to them, and were also responsible for overseeing all issues concerning cross-border trade. Macdonald was an Anglo-Sikkimese born to a Lepcha mother and Scottish tea-planter father. Though there was strong prejudice against Anglo-Indians in the establishment, his capability, fluent Tibetan and the patronage of Bell aided his rise in government. Pictures here relate to his time as a Trade Agent in Yatung between 1909 and 1917, and as joint Trade Agent for Yatung and Gyantse from 1918 to 1924. He also accompanied Bell to Lhasa in 1920.

Geographical and Ethnic Tibet

Though the mountains and deserts that surround Tibet have discouraged visitors, geographically the country lies at the heart of Asia. It can be visualized as a huge tableland nearly three miles high, lying between India to the south and west and China to the north and east. Its geological formation 45 million years ago was the result of continental drift that caused a very slow but cataclysmic collision between India, then an island, and the Eurasian land mass. At the point of impact the Himalayas were created. This

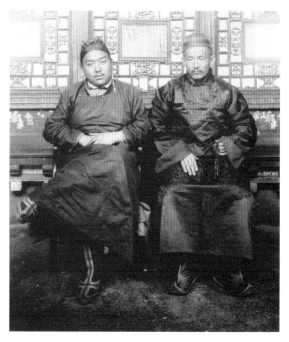

8. The Tibetan Postmaster General (on the left) sits next to a lama from Buriatia who holds a rosary. The Buriats are from a part of eastern Siberia between Mongolia and Lake Baikal, which was confirmed as Russian by a treaty of 1689. The population of Buriatia, a heavily forested area the size of Germany, has practised Tibetan Buddhism since the seventeenth century. This Buriat might be the lama whom Bell describes as having come to the capital in 1921 to repay money borrowed by his teacher from monasteries in Lhasa. Equally, he might be a visiting pilgrim or a student at one of the large monasteries around Lhasa.
Charles Bell

geological process continues, and the still-rising Himalayas are both the highest and the newest mountains on the earth. The end result of the whole geological process is that Tibet is ringed by mountains on three sides: the formidable Himalayas to the south and south-west, the Karakoram and Ladakh ranges to the west and the Kun Lun and Tangla mountains to the north. The eastern approaches lack mountain barriers and instead the land slopes gradually east into the Chinese provinces of Gansu, Sichuan and

Yunnan, being divided into deep parallel river gorges flowing north–south. The upper reaches of four of Asia's largest rivers, the Yellow (Huang Ho), the Yangtse, the Salween and the Mekong, flow through it into China, Myanmar (Burma) and Vietnam. The present-day Tibetan Autonomous Region, created by the Chinese in 1965, encloses 470,000 square miles of land, the same area as the UK, France and Germany combined, and yet the population is estimated at just under two million, less than a third of the population of London. While it is the area of highest altitude which is populated, it is at the same time one of the most sparsely peopled regions of the world at under five persons per square mile.

It must be remembered that the Tibetan Autonomous Region is far smaller than the area historically considered Tibetan territory by the Tibetans themselves, as most of two large former regions, Kham and Amdo, have now been included in the Chinese provinces of Sichuan and Qinghai. In addition, the cultural and ethnic sphere of 'Tibetanness' embraces to the south of the Himalayas the kingdom of Bhutan and the ex-kingdoms of Sikkim (united with the Indian Union in 1975) and Ladakh (independent until 1834, now part of India). On the borders of Tibet and Nepal, but now inside Nepal, are the former kingdom of Mustang and the Dolpo, Helambu and Shar-Khumbu regions. All speak dialects of Tibetan and use the same written language, a situation culturally akin to the speaking of different dialects of German by the Austrians and Swiss while the written language remains identical. To the north-east, the enormous territories of Mongolia were, from the sixteenth century onwards, one of the largest areas following Tibetan Buddhism outside Tibet. The most important cultural distinctions which make these areas culturally Tibetan are the practice of Tibetan Buddhism and a similar art and architecture. Social customs such as polyandry are also closely allied.

Tibet's close connections with its cultural satellites are vividly shown in Sir Charles Bell's photographs in which Mongolians, Nepalese, Indians, Sikkimese, Ladakhis and Buriats from Siberia are all present. Tibet was never as remote and inaccessible to Asians as it appeared to Europeans. The seeds of Tibet's culture were received from the surrounding countries: religion, art and material culture travelled there from India, China, central Asia and Nepal with the pilgrims, monks and traders who moved across the vast network of trade routes radiating from Tibet in all directions. Even during its period of closure, from the mid-eighteenth century onwards, several time-honoured groups from other Asian countries were allowed entry as pilgrims and traders. Both Chinese and Mongol military and political intervention have played decisive roles in Tibet's history, with China also being of major importance culturally. Before the Muslim invasions of the thirteenth century there were intimate contacts with northern India while Buddhism was being brought from its homeland there. The Nepalese were present from a very early period and were important as traders, shopkeepers and craftsmen, and Kashmiri Muslims and Ladakhis

formed a community in Lhasa. In addition to these age-old interactions with the rest of Asia, western missionaries and traders were there before the borders were closed. In the late seventeenth and early eighteenth centuries Jesuit and Capuchin missions operated openly, while there were small Armenian and Russian trading communities in the capital.

Early History

The Tibetan people are believed to have descended from the Qiang (or Chiang), nomadic shepherds living in northern China who first appeared in 1000 BCE. They migrated into Tibet and intermarried with the indigenous nomadic population and other Indo-Persian groups. The Tibetans belong to a separate branch of the Mongol peoples than the Chinese, their language too is distinct and only distantly related to Chinese. It is counted as part of the Tibeto-Burman group of Sino-Tibetan languages, though the script was adapted from Indian sources in the eighth century.

If we look back to the earliest period for which there are written records, i.e. between the seventh and ninth centuries, we find an expansionist Tibet with an Asian empire and a reputation as a feared military power. Songtsen Gampo, the first king (*tsenpo*) who emerges with any clarity (reigned 620–50 CE), ruled a confederation of principalities and tribes from his capital in the Yarlung Valley in the south of Tibet. He unified the Tibetan plateau under his rule, making Nepal a vassal state.

However, the most significant theatre of military operations at this time lay in central Asia, where Tibet's expansionist policy brought it increasingly into conflict with China as it sought to gain control of the key trade route through the region, the famous Silk Road. This caravan route linked India and Europe in the west to China in the east. Chinese silk and Indian ivory, gemstones and spices travelled west; bronze and glassware from Byzantium moved eastward. The Silk Road ran through important centres of Buddhist learning. It may have been here that the Tibetans first encountered Buddhism, as they captured a number of the most important city-states along its route from the seventh century onwards. By the end of the eighth century Tibet's empire encompassed large parts of central Asia and China, much of present-day Myanmar, Pakistan, Bangladesh and West Bengal, and all of Nepal, Bhutan and Sikkim.

Tibetan power was sometimes placated through marriage alliances. Both China and Nepal offered princesses to Songtsen Gampo in diplomatic moves to maintain peace. According to Tibetan legend, they introduced Buddhism and the first temples in Lhasa, the Ramoche and Jokhang, were built to house religious images brought from their countries. Songtsen Gampo was also responsible for other initiatives that laid the foundations for Tibetan culture in later centuries. He moved his capital to Lhasa and constructed a palace on the Red Hill now occupied by the Potala. The first criminal law code was formulated and a minister, Thonmi Sambhota, was sent to India with the task of adapting an existing script

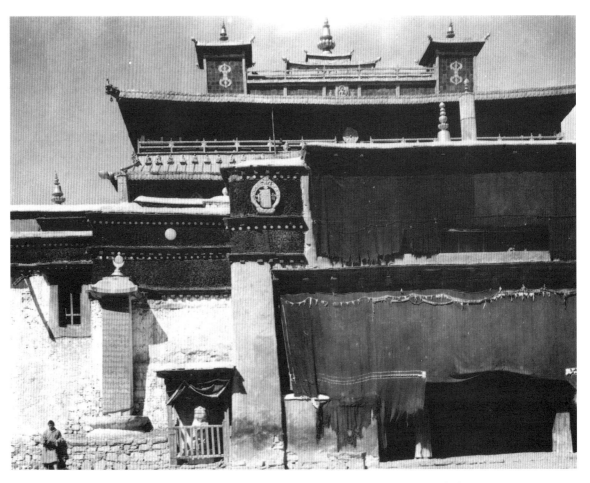

9. The entrance to the central temple at Samye monastery, showing the inscribed pillar (left)
erected in 779 CE by Trisong Detsen proclaiming Buddhism as the official religion of Tibet.
Charles Bell

to produce the first written Tibetan alphabet.

It is likely that during this period the life of the people had started to take on some of the basic characteristics that are so familiar from later periods. Chieftains and local kings ruled from hilltop forts while in the valleys communities were protected by stone walls and watch-towers. The Tang period annals of China show that highly developed metalworking skills existed in Tibet,

recording gifts to the emperor in both 641 and 648, in the first case of a large seven-foot-tall gold wine container in the shape of a goose. Tibetan blacksmiths also made extremely fine chain-mail armour, copied from Persia, which swords and arrows could not pierce. Tibet was already a trading nation exporting armour, weapons, horses, silver and gold bullion, textiles, salt and musk. In the next century the king, Trisong Detsen (742–97),

ordered the translation into Tibetan of large numbers of Indian and Chinese classics on astronomy, astrology, geomancy, medicine and, above all, Buddhism. For the Tibetans, the most important single contribution to their culture was undoubtedly that of Indian Buddhism, which from the eighth century was to predominate in Tibet for the next 1,200 years.

Though it is clear that Buddhism was strongly supported by Trisong Detsen, Tibetan kings practised both the indigenous religion and the new one right up until the end of the monarchy in the mid-ninth century. The old religion is sometimes called Bon (see p. 78), a term used in the monarchic period for priests carrying out the death ceremonies of the kings, but it is highly unlikely that this was the name Tibetans used for their native religion. There was a belief that the king would live on after death in an afterlife for which he was equipped in a way reminiscent of ancient Egypt with food, clothes and personal possessions. Large-scale animal sacrifice was performed at the time of death, and other ceremonies were carried out and gifts offered on the anniversary of passing. The pantheon of the time included other deities of the earth, soil, rocks, rivers and lakes. There were also tribal deities, 'divine hero' gods and hosts of malificent demons who could cause illness and death.

The Coming of Buddhism

In 779 CE, a little over one hundred years after the death of Songtsen Gampo, Trisong Detsen invited the Buddhist masters Santarakshita and Padmasambhava from India to establish the first Buddhist monastery at Samye, some 50 miles south-east of Lhasa (see figures 9 and 79). It was only from the reign of Trisong Detsen (742–97) that Buddhism began to gain popularity, albeit slowly, with other levels of society; before then it had remained confined to court circles. Nevertheless, opposition to it from the advocates of Bon continued and there remained strong pro and anti factions within the nobility. From Songtsen Gampo until nearly the middle of the ninth century the line of kings had been pro-Buddhist, but when Langdarma (803–42), a keen supporter of the old religion, ascended the throne in 838 he ordered the active persecution of Buddhists. When he was assassinated by a Buddhist monk in 842, the monarchy, and with it a strong patronage of Buddhism, collapsed. Though pockets of Buddhism survived on the periphery in western and north-eastern Tibet, in the centre it all but ceased to be practised. The successors of Langdarma fought for the throne but no strong central authority emerged and Tibet reverted to being a patchwork of warring petty kingdoms.

The Second Spreading

The reintroduction of Buddhism, called 'the second spreading' by Tibetans, began about a hundred years after the death of Langdarma when lamas returned to Lhasa from north-eastern Tibet. However, the real power behind this revival were the Buddhist kings of Guge in western Tibet, whose patronage enabled the brilliant monk

translator Rinchen Zangpo (958–1055) to make three trips to Kashmir, each time returning with texts and craftsmen. He is credited with founding over a hundred monasteries.

From the tenth century onwards, India was increasingly turned to as the authentic source of Buddhist teachings, a tendency accentuated by Tibet's loss of its central Asian territories in 866. It was another great scholar saint, Atisha (982–1055), invited from India by Yeshe O, the King of Guge, who was to have an even greater impact on the revival of Buddhism in central Tibet. Atisha, a Bengali master, was the most famous teacher of his time in India and was already 60 when he arrived in western Tibet in 1042. The tradition of teaching begun by Atisha, and passed on by his pupil Bromton, stressed the importance of monastic discipline and though esoteric tantric doctrines were taught, they were set firmly within this framework.

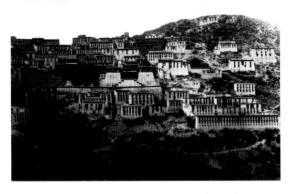

10. Ganden monastery, founded in 1409 on the site of the meditation retreat of Tsongkhapa, the founder of the Gelukpa order. It is built on a mountain ridge high above the Kyichu River. Tsongkhapa called it Ribo Ganden, the 'Joyous Mountain'. It housed 5,000 monks at the time Bell took this photograph in 1921. The larger dark (red) building to the left is the temple housing Tsongkhapa's tomb.
Charles Bell

Atisha's importance lies in his transplantation of a model of monasticism in Tibet which integrated magical and sexual practices, interpreted as symbols of inner processes, with a disciplined monastic life. Atisha saw this as a necessary corrective to the mixture of sometimes questionable teachings then current, which had been introduced piecemeal into Tibet. His successors founded the first new order, the Kadampa (meaning 'bound by command').

From the tenth to the early thirteenth century when Muslim invasions destroyed the monastic Buddhism of northern India, virtually the entire canon of scriptures and range of teachings were transferred from India to Tibet. Kashmir, in northwest India, and the Buddhist kingdom of Nepal were also sources of teachings. Although Indian teachers travelled to Tibet to spread new teachings, a still greater number of Tibetans braved the dangerous journey and the risk of disease in India to study at the great monastic universities or under solitary yogis. They returned having mastered the inner application of complex teachings and brought back texts with them, large numbers of which were translated into Tibetan at this time. The period from the eleventh to the fourteenth centuries was one of creative assimilation probably without equal in Tibetan history. These Buddhist teachings gave rise to the flowering of new monastic orders which, by the fourteenth century, possessed their own line of masters and commentarial literature. Painting and sculpture also flourished and provided the temples and monasteries with religious objects. Two other major orders of Tibetan Buddhism, the Sakya and the Kagyu,

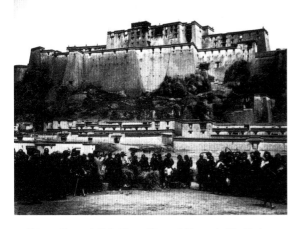

11. Shigatse Dzong, built by Karma Phuntsok Namgyal of the Nyak family, the ruler of Shigatse between 1611 and 1621. The Fifth Dalai Lama was enthroned here in 1642. The elegant form of this grey stone building became a prototype for the Potala Palace.
Charles Bell

trace their origins to Tibetan teachers who, returning from instruction in India at the end of the eleventh century, gathered their own disciples around them.

From the twelfth century onwards, the religious orders became increasingly wealthy and powerful as nobles and princes granted tax exemption to monastic lands and supported them politically. By the thirteenth century monastic orders had become centres of power in their own right, and rivalries had started to grow between them. This process kept power in Tibet decentralized until the seventeenth century when one order, the Gelukpas, became dominant. But while Tibet was inwardly focused on its religion a much greater external threat, in the form of Genghis Khan and the Mongol armies, had emerged on its border. Tibet, lacking a unified military command or indeed the strength to defend itself, submitted

to Mongol rule without a struggle. In 1249, the head of the Sakya order, Sakya Pandita, negotiated with the Mongol leader at his court. The arrangement they came to was effectively an exchange: in return for overall control of Tibet, the Mongols handed over internal political control to the Sakya order. The same arrangement was maintained by the next generation when Sakya Pandita's nephew and successor Phagpa renewed Tibet's submission to Kublai Khan. Phagpa became the guru of the Mongol emperor. From this time on dates the 'Patron–Priest' or Yon Chod relationship. By this the dominant secular power of the Mongols (as patron) was understood to be the protector of the religious power (the priest), in this case the Sakya order. Although this relationship ensured peace, it created a dangerous long-term precedent which allowed the Chinese to spuriously justify intervention in Tibetan affairs right up to the twentieth century.

The period of Sakya dominance ended about ten years before the collapse of the Mongol Yuan dynasty in 1368, when, for a short time, Tibet became independent under a remarkable secular leader, Chang Chub Gyaltsen (1302–64) of the Pagmotrupa family. Power passed in turn to other secular rulers, but in each case they were backed by the Kagyu order.

The Rule of the Dalai Lamas

The Geluk order, destined to become predominant in both the religious and political life of Tibet from the seventeenth to the twentieth

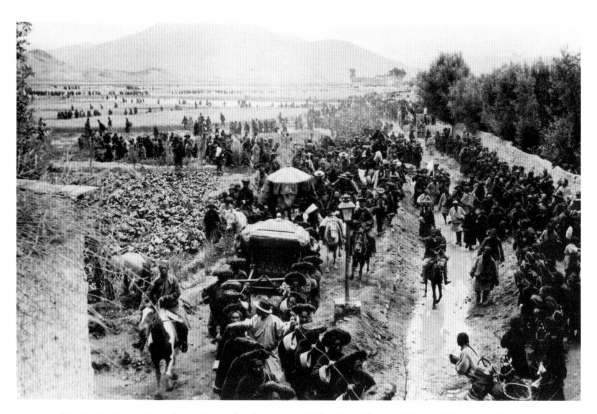

12. The Panchen Lama arrives at Gyantse in his sedan chair, accompanied by a large Chinese and Tibetan military escort. The occasion is his return to Tashilunpho from Lhasa in 1911, where the Chinese Amban had been trying to persuade him to become the Tibetan head of state (the Dalai Lama being in exile in India). He refused the offer.
David Macdonald

centuries was founded by Tsongkhapa (1357–1419) in the early fifteenth century. Tsongkhapa's teachings, integrating much from the Kadampa school, emphasized monastic discipline and morality. Their integrity led to his followers becoming known as the 'Virtuous Order'. The Gelukpas, followers of the Geluk order, grew quickly and though initially without political ambitions, by the end of the fifteenth century alliances had begun to be made with noble families and increasingly they entered into conflict with the older religious orders. Its critical struggle, which took

place during the sixteenth and early seventeenth centuries, was with the Black Hat Karmapas, who were a sub-order of the Kagyupas supported by the kings of Tsang. Eventually the intervention of the Gelukpas' allies, the newly converted Qosot Mongols, proved decisive in establishing Gelukpa power and the theocratic state.

When the abbot of Drepung, Sonam Gyatso (1543–88), visited the Mongol leader Altan Khan in 1578 to instruct him in Buddhism, the Khan, in a gesture of respect, conferred on him the title 'Ta Le' (Dalai), the Mongolian equivalent of his

name, Gyatso, meaning 'Ocean of Wisdom'. Sonam Gyatso is not, however, the First Dalai Lama but the Third as his two immediate predecessors as abbots of Drepung were retrospectively counted as the Second and First Dalai Lamas. The first use of the principle of reincarnation to determine the succession of a religious lineage actually took place in the twelfth century among the Karmapas. It was found to be an effective means of ensuring continuity within religious organizations which did not have the support of a powerful family, or had sometimes fragmented or disbanded following the death of a charismatic leader.

The rivalry between the Karmapas and the Gelukpas was resolved by the Fifth Dalai Lama, Nawang Losang Gyatso (1617–82), by his invitation to Gusri Khan, the leader of the Qosot Mongols, to use military force on his behalf. In 1642 the invading Mongol army defeated and killed the King of Tsang, thereby bringing to an end the political power of the Karmapas. Some of the monasteries of the Gelukpas' political rivals were then taken over and converted, though other orders were not oppressed. From this time on the Gelukpas became the dominant religious school. For the first time a Dalai Lama combined secular and religious authority, cementing the foundation of the theocratic state that survived until the Chinese stripped them of power in 1959.

The Fifth Dalai Lama is known to Tibetans as 'the Great Fifth' because of his outstanding character and achievements as a statesman, scholar and religious leader. In 1645 the building of the Potala Palace was begun. Today, this 13-storey 440-foot-tall building still dominates Lhasa (see figures 1 and 158) and remains the most visible single reminder of the power of the Dalai Lamas in the Tibetan world. The other great religious lineage of almost the same standing as the Dalai Lamas, that of the Panchen Lamas (see figure 12), was also founded at this time. The Fifth Dalai Lama declared Choki Gyaltsen (1570–1662), his tutor, to be an incarnation of the Buddha Amitabha and revealed that he would be reborn after his death in a recognizable successor. Thus began the institution of the Panchen Lamas, the title being a shortened form of 'Pandita Chenpo' meaning 'Great Teacher'. The Panchen Lamas are theoretically the seniors in the spiritual hierarchy to the Dalai Lamas who reincarnated the bodhisattva Avalokitesvara. In political terms, they were built up from the early eighteenth century onwards by the Chinese as a balance against the power of the Dalai Lamas, and a rivalry has existed into recent times.

The death of the Great Fifth in 1682 was kept secret for fourteen years by the Regent, Sangye Gyatso, in order to maintain his own power. In fact, the events of the life of the next Dalai Lama, Tsangyang Gyatso (1683–1706), tragically highlight the weaknesses of reincarnation as a system of succession. Out of the entire line of ruling Dalai Lamas from the sixteenth to the twentieth centuries, he was the only one who had no inclination to either the religious life or to government. Instead, the Sixth Dalai Lama was a romantic, a poet and a womanizer.

Kangzi, the Emperor of China, now became

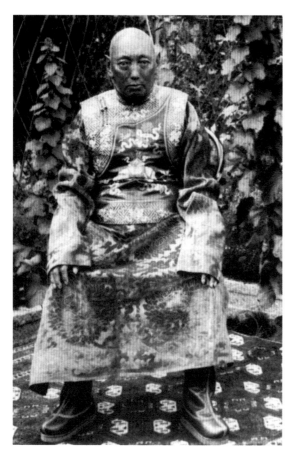

13. Thubten Gyatso, the Thirteenth Dalai Lama, a great lover of flowers and gardens, sitting in his own garden surrounded by hollyhocks. Taken in 1933, the year of his death.
F. Williamson

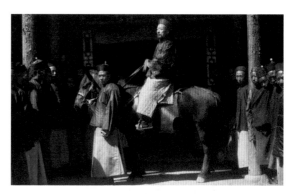

14. Youtai, the Chinese representative or Amban, in Lhasa in 1904. Youtai was a Mongol and was Amban in Lhasa from 1902 to 1906.
John Claude White

involved in Tibetan affairs. Fearing that an unstable Tibet might threaten his empire, in 1706 he supported the placing on the throne of a rival Dalai Lama by Lhazang Khan, a Mongol military leader. The Sixth Dalai Lama was deposed and murdered. There followed coup and counter-coup as the new Mongol-backed Dalai Lama was rejected by the Tibetan people and a new force of Mongols, the Dzungars, invaded Tibet in 1717. Chaos became the pretext for further Chinese intervention in 1720 when they installed Kalzang Gyatso (1708–57) as the newly recognized Seventh Dalai Lama. In a decree of 1721, Tibet was declared a vassal state to China and from 1727 until the Chinese were expelled from Tibet in 1913 a Chinese representative, the Amban (see figure 14) and an assistant, were stationed in Lhasa. Although decisions were meant to be referred to them, their real powers were limited and they were often marginalized by the Tibetan government. As the Qing dynasty weakened during the nineteenth century Tibet was able, for the most part, to govern itself and enjoyed something close to independence, despite the presence of the Amban and a small Chinese garrison in Lhasa.

Though the period was a stable one, Tibetan society was dominated by the interests of the Geluk church, which became evermore conservative and inward looking as the century wore on. A succession of Dalai Lamas from the Ninth to the Twelfth all died suspiciously early (between the ages of ten and twenty-one), quite possibly poisoned by the Regents. The period of the Thirteenth Dalai

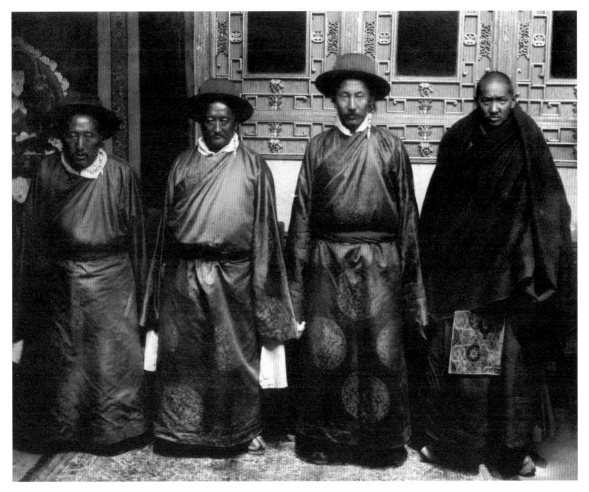

15. The four ministers of the Cabinet (Kashag), who negotiated the Lhasa Convention in 1904. From the left to right: the Lord Chamberlain (Chikyab Khenpo) Jamyang Tenzin Yuthok; Serchung Shapé; General (Depon) Wangchuk Gyalpo Tsarong; and Lama Chamba Tenzing.

John Claude White

Lama's government (1893–1933) was a critical one for Tibet in several respects. It was a time when Tibet was drawn against its will into a new age of international diplomacy where its old relationship with China was redefined by foreign powers.

Towards the end of the nineteenth century the British government, fearful of the rapidly expanding power of Russia in central Asia, believed that a Russo-Tibetan alliance could lead to Russian power advancing to the very Himalayas bordering India. Lacking personnel in Tibet, and with the exclusionist screen of Chinese power, the British found it almost impossible to communicate with the Tibetans. Tibet refused to acknowledge treaties with Britain made on its behalf by China in 1890 and 1893. By then, China's

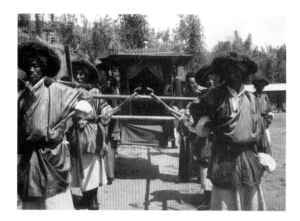

power in Tibet was weak, and though acknowledged when of diplomatic use in fending off the British, it was often ignored when expedient.

In 1903, when all attempts at communication failed, an expeditionary force of British soldiers under the command of Colonel Francis Younghusband was dispatched to the border to meet with representatives of the Tibetan government. However, after keeping the British waiting

16. The Dalai Lama's yellow silk-lined state palanquin (*pepchang*) being carried by servants. In 1947 Heinrich Harrer commented on the gorgeous spectacle of the 36 palanquin-bearers, resplendent in their green silk cloaks and red plate-shaped hats with tassels. The use of a palanquin was reserved for the Dalai and Panchen Lamas, Dorje Phagmo, the high female incarnate lama (see figure 105), and the Chinese Amban (see figure 14).
Charles Bell

17. The Thirteenth Dalai Lama on his throne in the Norbulingka Palace seated as when blessing pilgrims and receiving important persons. At the front of his raised throne hangs a white silk cloth bearing a design of crossed *dorjes* (see p. 84) in gold thread, signifying the unshakeable and immutable nature of Buddhahood. The nine scroll paintings of the Buddha behind the throne, together with the finely carved and painted woodwork, the pillars hung with silk streamers and the various pots of chrysanthemums and marigolds, create an impression of brilliance and magnificence.
Charles Bell

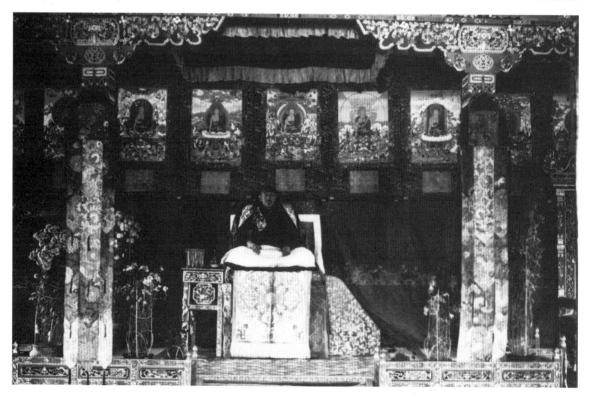

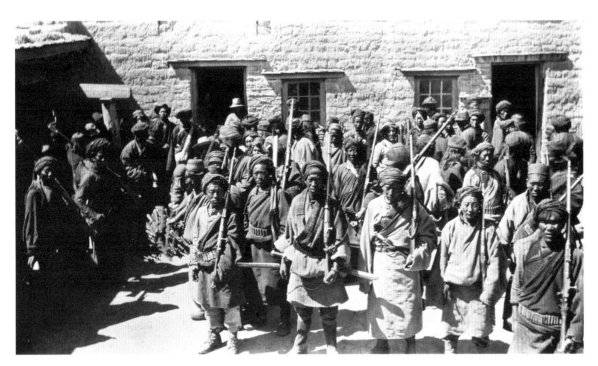

18. Tibetan soldiers at Gyantse before the Chinese invasion of central Tibet in 1910. At this time the army consisted of less than 5,000 ill-trained troops provided by the nobility. The soldiers in this picture carry an assortment of arms: breech-loading rifles of the type issued to the Indian army from the 1880s onwards, swords (fourth and sixth man from right), and one double-barrelled shotgun (fifth man from right). Compare these soldiers with those in figure 19, after using British drill and training methods.
David Macdonald

for three months at Khampa Dzong (see figures 23 and 24), a fortress just inside the border, the Tibetans refused to cooperate. At the end of the year the British government authorized a further advance, first to Gyantse and eventually to Lhasa itself. The Dalai Lama fled to Outer Mongolia and in Lhasa the Amban claimed he had no authority to negotiate. An agreement, the Lhasa Convention, was eventually reached with the Cabinet (see figure 15) in which both the British border demands were met and the Tibetans agreed, in future, to negotiate directly with the British. It was not until 1908 that the Chinese agreed to the convention but by then a number of the key terms had been changed. In 1914, at Simla, another attempt was made to define the relationship between Britain, Tibet and China. However, the Chinese now claimed that Tibet was an integral part of China, a claim completely rejected by the Tibetans. A compromise solution was proposed by the British whereby China's suzerainty over the whole of Tibet was recognized in return for an undertaking that the Chinese would not attempt to directly colonize Tibet. By this agreement Britain hoped to maintain the loose Chinese control over Tibet, which kept it free from other foreign interference while allowing it to remain an autonomous buffer for India.

As the Chinese refused to sign the Simla Agreement, the British negotiated a separate treaty with Tibet recognizing its autonomy and denying Chinese suzerainty unless and until they signed.

The immediate result of the 1903–4 expedition was to galvanize China into invading Tibet; they were now fully aware of its strategic importance and the comparative ease with which a British force had advanced to Lhasa. From August 1905 the Chinese forces advanced rapidly inside eastern Tibet. In December 1909, less than two months after the Thirteenth Dalai Lama's return from exile, a Chinese army was within striking distance of Lhasa and he was forced to flee again, this time being given sanctuary in Darjeeling by the British. However, in 1911 the Qing dynasty was overthrown, significantly weakening the Chinese

grip on Tibet. The Dalai Lama returned to Lhasa in January 1913 and proclaimed Tibet independent. The remaining Chinese troops were deported via India.

The Thirteenth Dalai Lama, Tubten Gyatso (1876–1933, see figures 4 and 17), is regarded by Tibetans as one of their greatest leaders and is often referred to as 'the bodhisattva warrior' for his role in liberating Tibet from China. He was a strong character with a shrewd judgement and insight into Chinese diplomatic methods. The Tibetans' views about the British began to change from the time of his return. From aggressors they began to be seen much more favourably and even as potential protectors. Their disciplined withdrawal from Lhasa in 1904 and their restraint in not destroying religious buildings was compared to Chinese mass executions and destruction of monasteries. But above all it was the good treatment and protection given to the Dalai Lama while in exile which impressed both him and his people. The Tibetan ruler's time in India and his association with Charles Bell increased an already existing belief in the need for change in Tibet. He saw clearly the need for reforms to the army and to the educational system in order to enable Tibet to become a strong independent nation. Moves

19. Soldiers trained using British drill on parade in Lhasa. The growing entente between Britain and Tibet after the Dalai Lama's return from exile in India in 1913 led to the adoption of British methods of military training. Tibetan soldiers were sent to Gyantse in groups to be trained under the British and Indian officers of the Trade Agent's escort. Commands were given in English and uniforms were locally made versions of British military attire. The Tibetans made copies of Indian army rifles at the arsenal just outside Lhasa.
Charles Bell

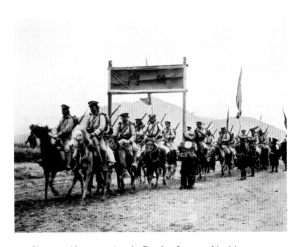

20. Chinese soldiers escorting the Panchen Lama on his visit to, or return from, Lhasa in 1911. On his return, passing through Gyantse, Macdonald noted that he was escorted by 100 Chinese and 150 Tibetan mounted troops. The Chinese troops were a better disciplined and equipped force than troops in Tibet at that time (see figure 125).
Henry Martin

were first made to increase and improve the army (see figure 19), but the Dalai Lama was, tragically, unable to carry through the changes in the face of monastic opposition. On several occasions monks demonstrated in their thousands against the growth of the army and in 1921 threatened to attack Lhasa. The Dalai Lama sent 3,000 troops against them, arresting and flogging a number. Though for a time he showed himself to be the master, in the longer term he opted for conciliation. The Dalai Lama was, perhaps, also afraid of the potentially dangerous power of a reorganized and expanded army. By 1925, as opposition to reform mounted, he drew back, cutting off supplies to the army and demoting officers. Both the army and the police force decreased in size and strength and the English school at Gyantse, opened in 1923 in an attempt to modernize the

educational system, was closed after just three years. His was perhaps the last opportunity to challenge the power of the monastic establishment.

Chinese Invasion and Occupation

Even before the Chinese Communists took power, Chinese nationalists were declaring Tibet part of China, one of the clearest early claims being at the proclamation of the New Republic of China in 1912. Tibet remained neutral during the Second World War, but all through this period British power helped maintain the status quo. The situation changed when India gained its independence in 1947 and the power of the Communists grew in China. In October 1950 the Chinese massed an army of about 20,000 trained and seasoned soldiers on the Tibetan border. Attacking on several fronts in eastern and north-eastern Tibet, they met little resistance from the few thousand poorly trained Tibetan troops. Tibet's defeat was undoubtedly speeded by the surrender of Ngabo Ngawang Jigme, the Tibetan commander in Chamdo, who, having lost his nerve, fled into the night abandoning his men. By this time the fifteen-year-old Fourteenth Dalai Lama, Tenzin Gyatso, who had been recognized in 1939, had been installed with full powers at the request of the State Oracle. A delegation from his government negotiated an agreement with China, the Seventeen Point Agreement, which guaranteed to protect the status and position of the Tibetan

government, the Dalai Lama and the established religion. The Dalai Lama, who had withdrawn with his Cabinet to the border town of Yatung, returned in 1951 to a Lhasa occupied by over 20,000 Chinese troops. At first the Tibetan government tried to work with the Chinese, and for a few years the internal government of Tibet continued to be run as before. But by the mid-1950s 'reforms' became increasingly radical and repressive, including the deportation of children to China, the confiscation of estates, the destruction of monasteries and the imposition of high levels of taxation. Eastern and north-eastern Tibet were placed under direct Chinese control and large-scale changes that threatened the old lifestyles were introduced: cooperatives were established, nomads were forcibly settled and religion was suppressed. The anger of the Tibetan people finally found expression in 1956 when a revolt erupted in eastern Tibet which steadily extended to central areas. Then in March 1959 a spontaneous uprising against the Chinese broke out in Lhasa when the populace believed that the Dalai Lama was about to be kidnapped. However, by this time the Dalai Lama had already fled the capital and was travelling south towards the border and into exile. The revolt was uncoordinated and with only a small part of the population taking part, it was crushed within about two weeks. The Chinese regarded the action as a breach of the Seventeen Point Agreement and dissolved the Tibetan government. From this point onwards the Chinese undertook the systematic destruction of the institutions of Tibet, stripping monasteries of their authority and

placing government in the hands of the Chinese-dominated Preparatory Committee for the Tibetan Region. Although the dismantling of traditional Tibetan society was well under way by the early 1960s, the process underwent a frightening intensification during the Cultural Revolution. Red Guards entered Tibet and began to demolish its monasteries and temples, often forcing local people to take part. Thousands of people from every level of society, but especially monks, nuns and nobles, were imprisoned, tortured or executed. By 1975, with 90 per cent of the peasant farms collectivized, the sharp decline in productivity at a time when Tibet's population was increasing rapidly as Chinese flooded in, inevitably resulted in famine.

Since 1980 many of the restrictions on worship have been relaxed, collectivization reversed and the remaining monasteries allowed to take in a limited number of monks. However, a longer-term threat to Tibet has emerged in the form of the Chinese policy of encouraging large-scale Han Chinese settlement in Tibet, a process which will eventually make Tibetans a minority in their own country. Of the 6,000 monasteries that formerly existed only about 6 remained substantially intact after the destructive whirlwind. The townscapes too are different now with standard communist concrete-block architecture often swamping local buildings.

The 120,000 Tibetans who followed the Dalai Lama into exile have kept important elements of their culture alive. The Tibetan government in exile in Dharmasala has been restructured by the Fourteenth Dalai Lama, who has sought to intro-

duce democratic ideas. Many of the large monas-
teries have been refounded in India and, even in
climatically alien areas such as southern India,
Tibetan communities have done remarkably well
both economically and culturally. Most of the
colourful panoply of the ancient feudal state, the
costumes of the aristocracy, the etiquette and large
festivals seen in these photographs, have had to be
abandoned. But the most important elements of
Tibetan culture – its Buddhist traditions, art, drama
and medicine – have been kept alive and have start-
ed to grow again both in India and the west.

Tibet today is regarded very differently
according to the cultural perspective of the obser-
ver. China continues to see the Tibetans as a
backward, primitive people, a view easily refuted
by looking at Tibet's cultural and religious
achievements. Meanwhile in the west the various
imaginary Tibets of the popular imagination have
come under the scrutiny of academics. But while it
is comparatively easy to deconstruct a mythical
image with its roots in history it has now become
more difficult to attempt an intelligent, positive
re-evaluation of the culture itself without being
accused of buying back into the romantic myths of
the past. For any western view to have integrity
and worth it must come from among the small
number of acculturated, linguistically fluent west-
erners who have lived in the few remaining
pockets where the culture survives in a relatively
untouched form. The one or two courageous
individuals from this group who have recently
written appreciatively of the culture have done so
in psychological, social and ecological terms.

The strengths of Tibetan Buddhist culture are
seen by them as centring on the sense of meaning
and belonging felt by people in their lives, their
self-esteem and the time which people are able to
give one another. These qualities are described as
the result of an interaction between Buddhism as a
belief system, emphasizing interconnectedness and
compassion, and social forms that promote cooper-
ation and mutual support. Buddhism is obviously
of major importance in enabling the individual to
integrate the facts of suffering in a meaningful way,
bringing about a sense of security and equanimity.
It was Buddhism, permeating all levels of Tibetan
society, which softened and transformed what
might otherwise have been a harsh feudal regime.
We must also not forget the Tibetans' famous high
spirits and capacity for laughter, which arise from
all these factors, and from a happiness based more
on being than acquiring.

Climate, Landscape and Agriculture

Tibet is far from simply a uniform area of high plateau. Within its borders are landscapes of outstanding beauty and surprising variety. Much of the country experiences a desert climate but this is modified by its high altitude and comparatively low latitude, giving dryness with extremes of heat and cold. Temperatures alternate rapidly and by large amounts, from a winter's night temperature of -30°C, for example, to a day figure of 10°C. Summers are short but can be hot. The air is phenomenally clear and until now unpolluted, though fiercely strong winds laden with dust are common. Hailstorms have always been a great danger to crops, animals, tents and even people, with stones the size of tennis-balls sometimes falling. A class of magicians (see figure 21) was paid to prevent damage from them.

Variations in the height of the land and the amounts of rainfall falling on it have created three broad variations in farming patterns: the high plateau of the north (the Changthang), the grasslands and valleys of the north-east (Amdo) and the east (Kham), and the south dominated by the broad valley of the Yarlung River and its tributaries. The Changthang, standing at 15,000 feet or over, makes up nearly half of Tibet's area. This bare stormswept upland is too cold and high for either crops or trees

to grow. The land here is a mixture of deserts, glaciers, bog and stunted grass, but is also studded with salt lakes which have no outlet. Potash, soda and borax are found around their edges. The area is almost entirely uninhabited except for roving salt collectors, hunters and nomads.

The second division of the country includes the aforementioned north-east (Amdo) and the east (Kham), both of which contain rolling high-altitude pasture at above 10,000 feet. The largest areas of grassland are in the north-east around the giant Kokonor Lake, which extends over an area 60 miles long and 40 miles wide. Here the population is largely nomadic. Nomads or *drokpa* (*drok* means pasture in Tibetan) rely on the milk and meat products from their herds of yaks, sheep and goats to survive. The yak in particular is their key animal as it provides butter, milk, cheese, fuel (dried dung), hair for rope and the fabric for their large black tents and for blankets. The former eastern province of Kham is an area of good pasture and fertile river valleys descending to 6,000 feet in parts and, catching the monsoons of Assam and Yunnan, has much higher rainfall than the rest of Tibet.

In the south lies the political and cultural heartland of the country, the provinces of central (U) and southern Tibet (Tsang). Most of Tibet's

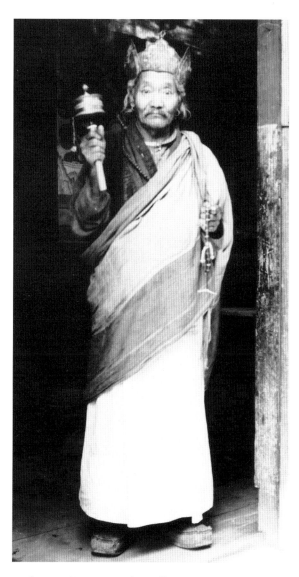

21. A *nagpa* or itinerant tantric lama at Yatung. He wears the hat of the Nyingma order and carries a prayer-wheel and rosary. *Nagpas* specialized in magical operations, particularly the prevention of frost and hailstorms that could destroy crops. It was usual practice for farmers to pay an annual fee of grain to them while the government in Lhasa granted plots of land in return for preventing hail falling on the Potala, Norbulingka or Jokhang. Prevention depended on exorcising certain spirits of the air by means of prayers and blasts on a trumpet made out of a human thigh-bone as the storm clouds approached. As a final resort 'thunderbolts' created from magically transformed mustard seeds or balls of mud were hurled. Some *nagpas* would also perform black magic.
Charles Bell

population is concentrated here and in the east (Kham). The long fertile valley of the Yarlung River and its tributaries such as the Kyichu, on which Lhasa stands, provide good agricultural land at between 11,000 and 12,000 feet. Some of Tibet's most important towns and monasteries are dotted throughout this area. Willow, walnut and birch trees grow along the wide valleys, where most of the farms are located. Farmhouses are set in small fields irrigated with water from mountain streams and rivers. Wheat, barley, mustard, peas and a few vegetables such as turnips, radishes and potatoes are cultivated. In much of the country, with the exception of the east and the Chumbi Valley in the south, wheat cannot be cultivated due to the high altitudes, hence barley is the main cereal crop as it grows in altitudes of up to and even beyond 15,000 feet. Yaks, cows, goats, ponies and donkeys are the most commonly found animals. A cross-breed of the yak with the ox, the more docile dzo, is also widely bred, the female or dzo-mo being a better milker than the yak.

Until the 1950s most small farmers rented their lands from the nobility, the monasteries or the government and paid their rent in kind, mostly in barley but sometimes in wool and butter, or by giving their unpaid labour to their lord, cultivating his estates and doing other work when necessary, such as digging irrigation channels and providing transport. The pastoral and agricultural economies were interdependent. The nomads traded their surplus meat, butter, cheese and wool and the salt and soda they collected for the barley from lowland farmers and for other imported items such as tea.

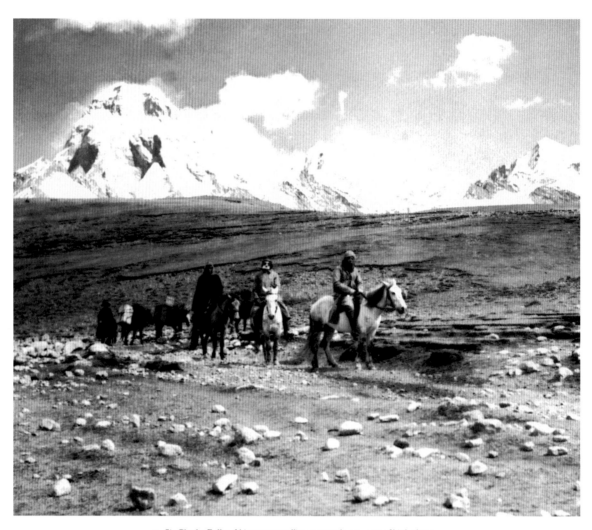

22. Sir Charles Bell and his party travelling across a barren area of high plateau.
From Bell's archive, photographer unknown

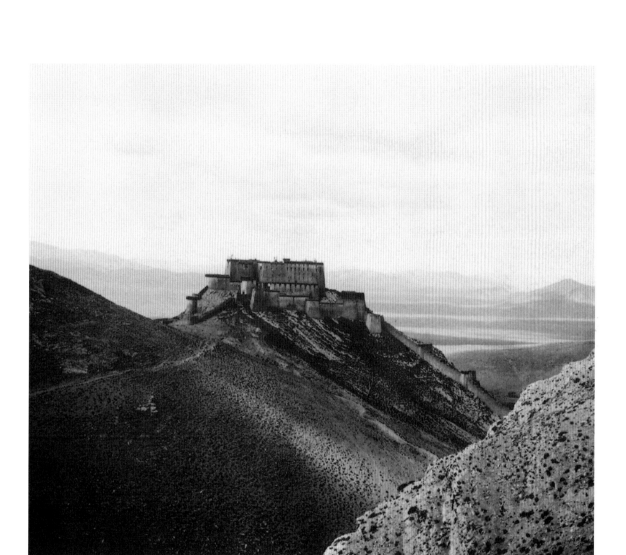

23. Khampa Dzong from a distance.
John Claude White

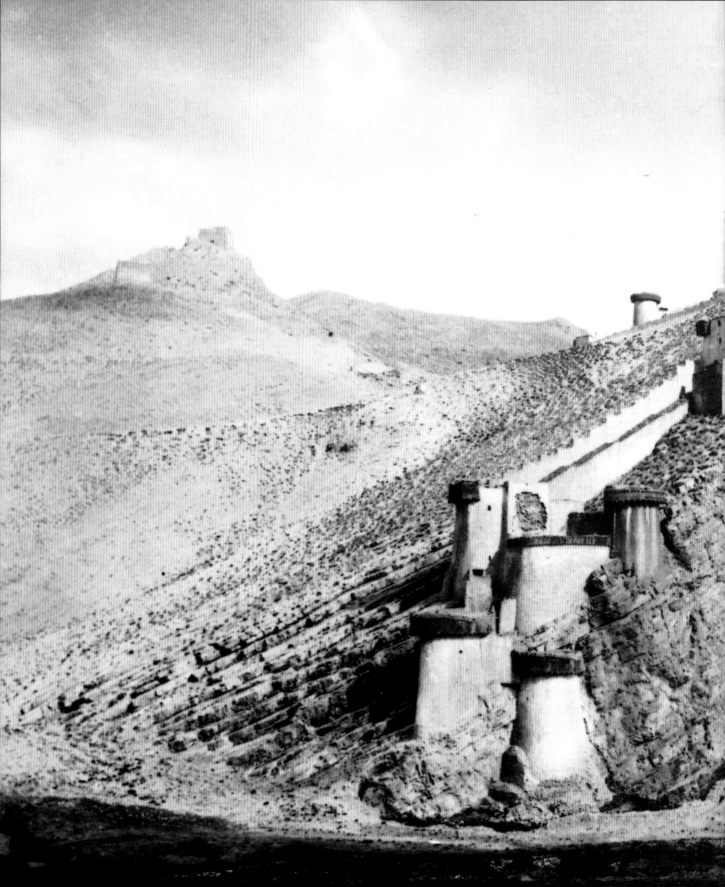

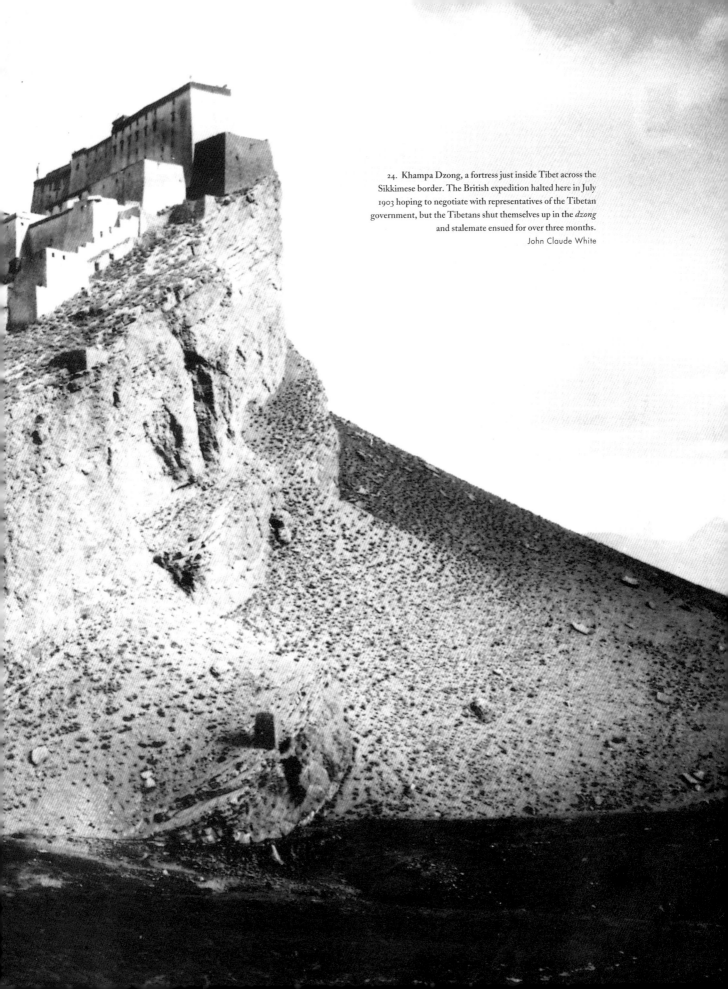

24. Khampa Dzong, a fortress just inside Tibet across the Sikkimese border. The British expedition halted here in July 1903 hoping to negotiate with representatives of the Tibetan government, but the Tibetans shut themselves up in the *dzong* and stalemate ensued for over three months.
John Claude White

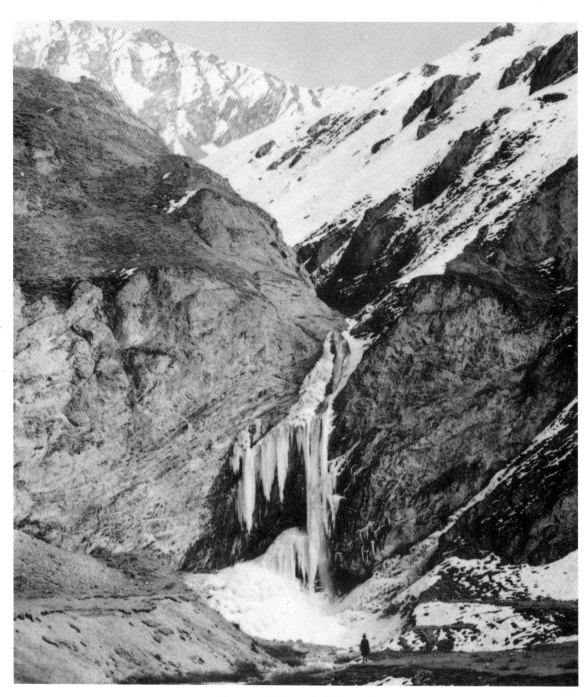

25. A frozen waterfall spectacularly demonstrating
the dry subzero temperatures of the Tibetan winter.
Charles Bell

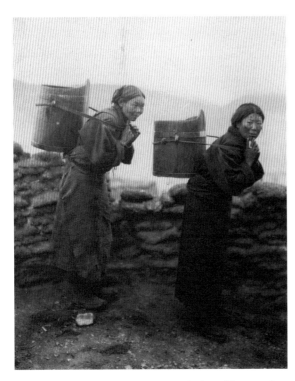

26. Two women of Phari carrying water in buckets. All water used
in the house had to be carried from nearby streams or wells, usually twice
daily, in the morning and evening. Drawing water at the well was the
occasion for finding out the local news and gossip.
Charles Bell

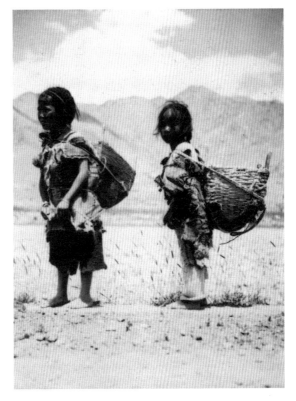

27. Two girls of six or seven carrying baskets of dung which they
have collected from the road. It will be used as fuel. It was usual for boys
and girls to be helping out from an early age, gathering fuel, drawing water
and looking after sheep, goats or cattle.
Charles Bell

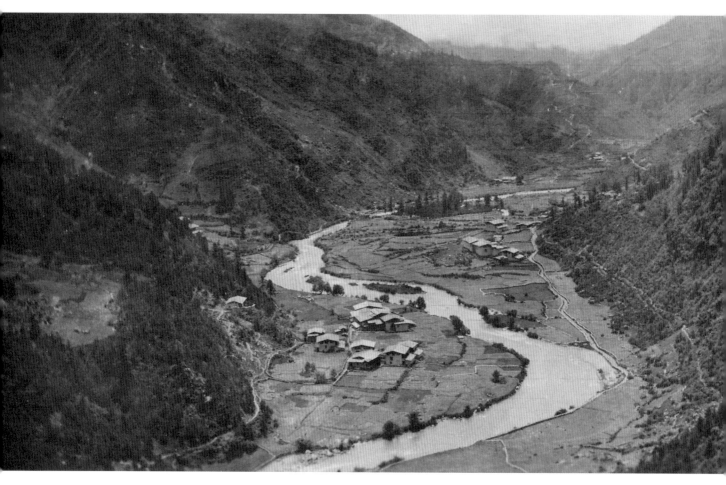

28. The Chumbi Valley (Tromo) near Pipitang close to Yatung. The Chumbi Valley is a tongue of Tibetan territory between Sikkim and Bhutan lying at between 10,000 and 11,000 feet. Low altitude and abundant rainfall make it one of the few wheat-growing areas in Tibet, its Tibetan name Tromo meaning 'wheat district'. Its prosperity was largely due to its position as a natural trade corridor between India and Tibet, and by the 1920s it carried over half of the trade between the two countries. The houses were built with roofs of sloping pine shingles as protection against the rain (see figure 83).
David Macdonald

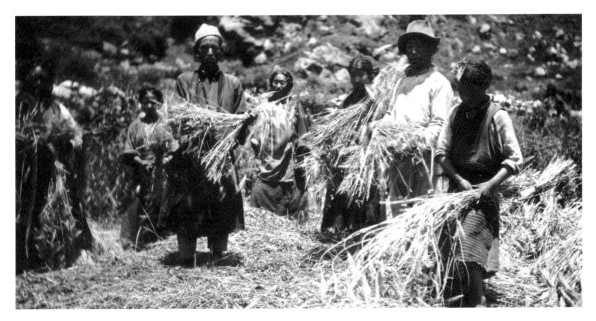

29. Men and women in the Chumbi Valley (Tromo) share the work of reaping barley and tying it in sheaves. After this it is carried to stacks to be dried. Finally, the barley heads are broken off and taken to be threshed and winnowed. Here, at 11,000 feet or less the harvest month is July or August (at the higher altitudes of central and southern Tibet it tends to be September). It was so important to get the crops harvested before hail or frost could destroy them that farmers would work around the clock, starting as early as one or two o'clock in the morning.
Charles Bell

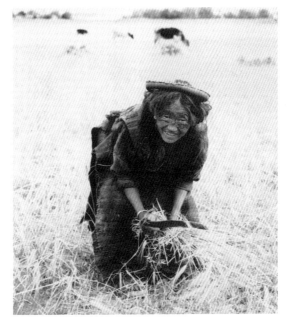

30. Woman reaping barley at Gongkar in central Tibet. She uses a sickle and wears a version of the Lhasa head-dress (see figure 131). Her face is darkened with a red paste made from cutch to protect her skin from the wind.
Charles Bell

31. Threshing barley and peas together at Gongkar. In Tibet two crops were often grown together and separated during threshing. The woman on the left threshes them with a wooden flail. The heads are then put through the bamboo sieve that the woman on the right holds. The peas remain behind. In other places threshing was done by making yaks or other cattle trample the crop, often while they walked in a circle.
Charles Bell

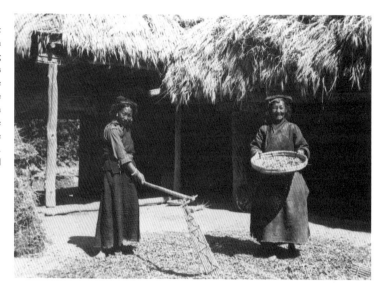

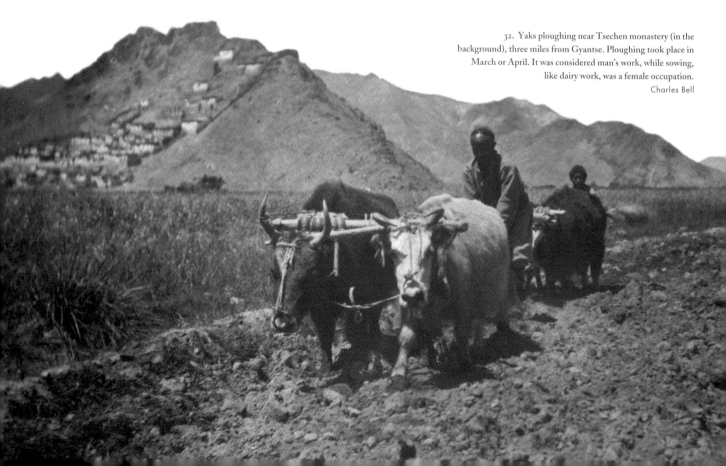

32. Yaks ploughing near Tsechen monastery (in the background), three miles from Gyantse. Ploughing took place in March or April. It was considered man's work, while sowing, like dairy work, was a female occupation.
Charles Bell

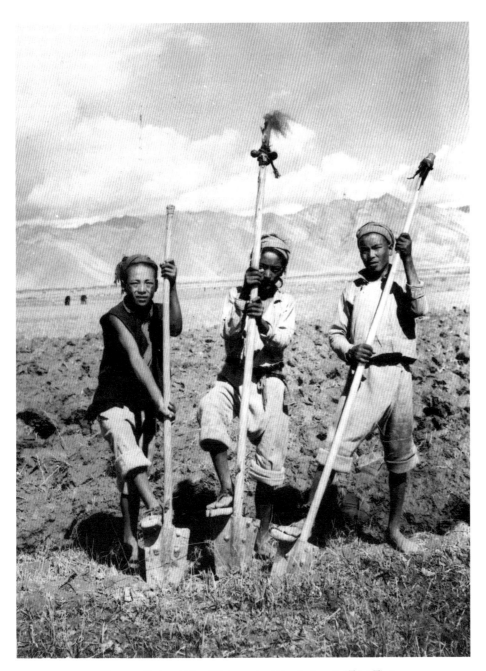

33. Three men digging with long Tibetan spades at Gongkar in central Tibet. The two
spades on the right have bells on the top, simply to give pleasure during the repetitive
task. Most did not have them. Manual work was often carried out while singing and
many tasks had their own special songs.

Charles Bell

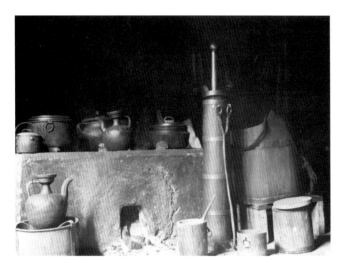

34. A stove with teapots and cooking pots in a typical Tibetan kitchen. The cylindrical tube with plunger is used for making butter tea. Chinese brick tea was always preferred in Tibet to the loose-leaf Indian variety. After boiling with soda and water on the stove, the tea was poured through a strainer into the churn (*chadong*) and butter and salt added. After vigorous mixing it was poured into an earthenware teapot and kept warm either on the stove or on a brazier, such as the one in the left-hand corner. Wooden *tsampa* (roasted barley flour) containers stand in front of the tea churn and a water bucket behind it.
Charles Bell

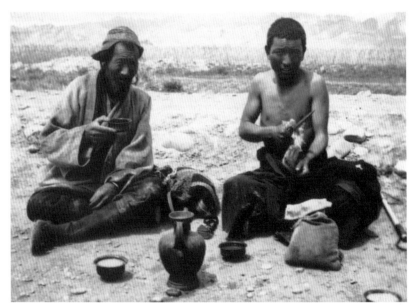

35. Men eating a midday meal in the open air, perhaps they are on a journey or working in fields nearby. The man on the right, who has thrown off the top of his *chupa* in the heat, cuts a slice off a piece of dried mutton or yak. Sun- or air-dried meat could be stored for up to nine months in the cool dark atmosphere of Tibetan storerooms. The bag will contain *tsampa* (roasted barley flour), which is the staple food of Tibet. It is usually mixed with tea and rolled into balls. The men are either drinking tea or beer from wooden cups, which at other times are stored in the folds of their *chupas*.
Charles Bell

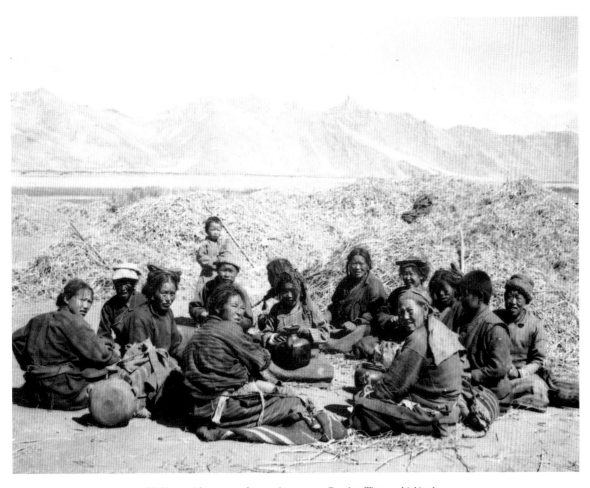

36. Midday meal for a group of women harvesters at Gongkar. They are drinking beer, an
iron beer jug stands in the left foreground. The teapot in the centre may also contain beer.
Roasted barley flour or *tsampa* will be taken out of the small bags stored in their *chupas*.
Charles Bell

Trade, Travel and Communications

Travel has never been an easy process in Tibet and yet throughout history the movement of people and goods, especially on pilgrimage or in trade, has been central to the life of the nation. Trade roads or routes are often spoken about but in reality most were nothing more than trackways. Travel was very slow and there was no wheeled transport in Tibet. The 300 miles from Darjeeling in India to Lhasa, a main trade corridor, took six weeks by horse. Bridges were rare, and those that existed were either simple suspension bridges made of hide, rope and wood or were of a cantilever type, with successive stages projecting from each side to meet in the middle. In the mid-fifteenth century the Tibetan saint Thangtong Gyalpo initiated the construction of iron-chain suspension bridges (see figure 37) throughout Tibet and Bhutan. But in general bridges were few and far between and those needing to cross the greatest river artery in central southern Tibet, the Yarlung River, used coracles, small lightweight boats made of yak hide stretched over thorn-scrub or willow frames, or the few flat-bottomed wooden-planked ferries that carried heavier loads and larger numbers of animals (see figure 39). There was a postal service (see figure 45), but this was operated by and for the government only. Private letters would be sent by friends who hap-pened to be travelling in the right direction, by hired messengers or, if one was a noble, by one's tenants.

Travelling was done on foot if one was poor or on pilgrimage but otherwise by pony, mule, horse or yak (yaks were better at higher altitudes and on rougher terrain). Travellers faced freezing night-time temperatures in winter, dust and wind storms that frequently set in by midday, as well as the threat of bandits on the road. For their own protection, traders and pilgrims wherever possible travelled in armed groups. Despite these difficulties the caravan routes and tracks of Tibet were busy with a colourful assortment of human traffic: pilgrims, traders, beggars, religious itinerants and magicians, travelling players, storytellers, tinkers and robbers.

Although there were not many full-time traders in Tibet, the most significant sections of the community, including herdsmen, farmers, nobles and monks, all traded regularly. As most of the necessities of life were produced in Tibet itself much of this trade was in the form of barter between groups within the country, though luxury goods such as silks and tea were imported from abroad. The aristocracy had commercial agents who managed the produce of their estates, and others who went to the borders of Tibet or even to China and Mongolia to buy luxury items. Amongst the full-time traders were to be

found Ladakhis and the Nepalese (see figure 7). Traders travelled in sometimes very large caravans of mules, donkeys or yaks (for instance, the tea caravans returning from the Chinese border could consist of hundreds of yaks).

Tibet's main exports were wool, yak tails (used as fly whisks), furs, musk (from the glands of the musk deer), borax, salt and gold-dust. Of these, wool was by far the largest export, with most of it going to Europe via India (five to six thousand mule loads went annually in the mid-1940s). From India, Tibet obtained cotton goods, hardware, precious stones, tobacco, dried fruits, sugar and small manu-factured items such as matches, needles and soap. Also through India came the Mediterranean coral and Iranian turquoise so highly prized in Tibet as decoration in jewellery and head-dresses (see figures 131 and 132). However, the largest import trade was in Chinese brick tea which came by way of Tachienlu on the border. Bricks were stitched into yak hides and loaded on to yaks, donkeys or mules for the 1,000-mile journey from China to the interior of Tibet. Silks, brocades, cotton goods and scarves were also imported from China in exchange for Tibetan musk, gold-dust, wool and furs. Often trade and pilgrimage were combined. For example, pilgrims from Mongolia visiting the shrines of Lhasa (see figure 46) would bring goods to sell in the capital to finance their trip. At the same time Mongolian traders going to Lhasa with Chinese silver, silk and ponies would, as a matter of course, visit the holy places once they arrived. ·

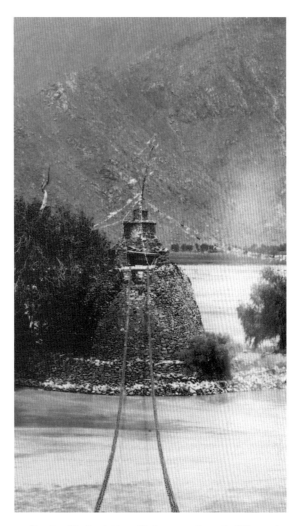

37. Remains of the iron bridge at Chaksam, 40 miles south of Lhasa and the site of a main ferry crossing point on the Yarlung River. The bridge was no longer in use, the river having cut into the piers on which it was anchored. It was one of the iron-chain bridges built by the saint Thangtong Gyalpo in the mid-fifteenth century. Stories of the life of Thangtong Gyalpo relate how an incident when he fired an arrow into the Kyichu River became an omen, inspiring him to build bridges for the good of all. The saint travelled to Kongpo in south-east Tibet where he found sponsors and iron sources for his constructions.
John Claude White

38. Bell writes: 'The Dzongpon of Tsona being carried to the coracle
at the Tsethang ferry. He is on his way from Tsona to Lhasa with
a mountain of luggage, a small part of which he takes in the coracle.'
Though boatmen could carry coracles on their shoulders, once in the water
these vessels were capable of carrying eight or nine men, plus animals and goods.
Charles Bell

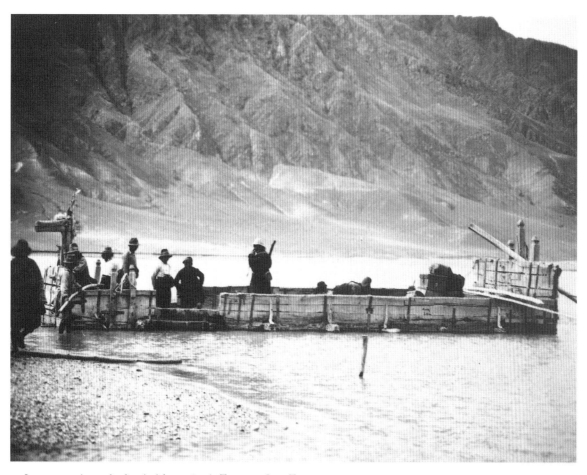

39. Large rectangular wooden ferry (*tru*) for crossing the Tsangpo at Gerpa Tru,
one and a half miles from Tsethang. Horse or mule caravans had, by necessity, to use
ferries like these. The horse's head (at left) was a traditional prow decoration.
Charles Bell

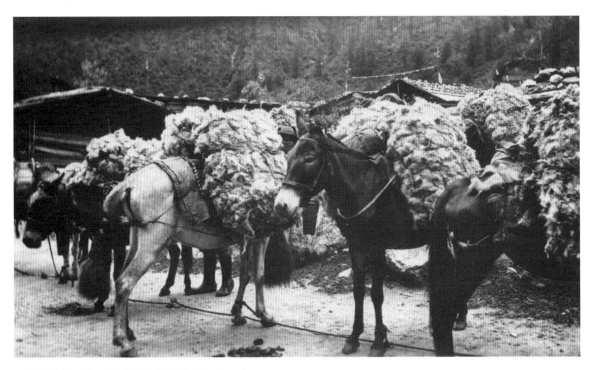

40. Mules laden with wool in the Chumbi Valley, the main trade route out
of Tibet for wool. The trade was monopolized by a number of buyers and carriers.
Chumbi carriers controlled the transport of wool from Phari to the Indian
border town of Kalimpong, 95 miles away, where many of the big dealers lived.
Most wool was loaded on to pack animals, each carrying two standard 90-pound loads.
On the journey down to India, loads were carried by yaks to Yatung.
Beyond that they had to be transferred to mules as at altitudes lower than 10,000 feet
yaks tended to sicken, at 8,000 feet or under they died. At Kalimpong,
foreign buyers, including Americans by the 1930s, took the wool.
Charles Bell

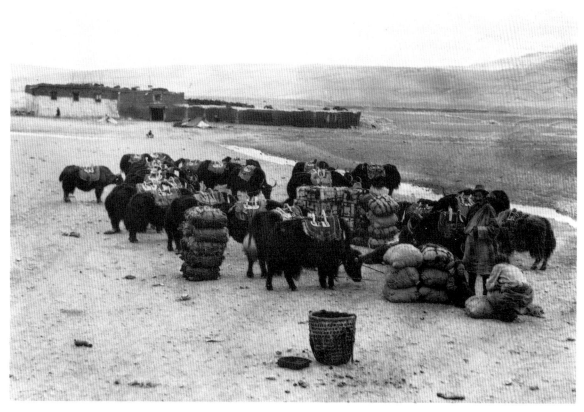

41. Yaks at Phari being loaded with grain for other districts. In the background
is the Phari plain (at 15,000 feet) and the surrounding hills. Phari stands at
the head of the Chumbi Valley, known for its abundant crops of wheat and barley.
The grain has probably come up from there, and would have been
traded for wool or salt from northern Tibet.
Charles Bell

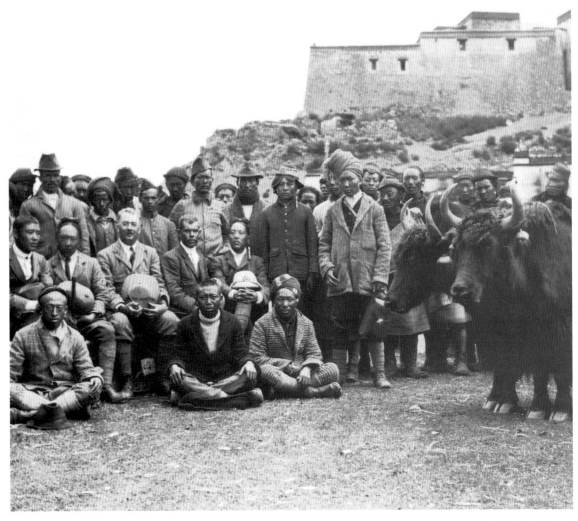

42. Indian and Tibetan workers and officials engaged in extending the telegraph line from Gyantse to Lhasa in 1920. The European seated left of centre is W. H. King, Assistant Engineer of the Indian Telegraphic Department, deputed to the job from Delhi. To his immediate right sits Kyipu, Tibetan Director of Telegraphs and one of the four boys sent to study at Rugby (see figure 5). To King's left is W. P. Rosemeyer, the Anglo-Indian telegraphic engineer who made several subsequent trips to Lhasa to service the line. To Rosemeyer's left is another old Rugbeian, Ringang, no doubt brought along as translator.
Charles Bell

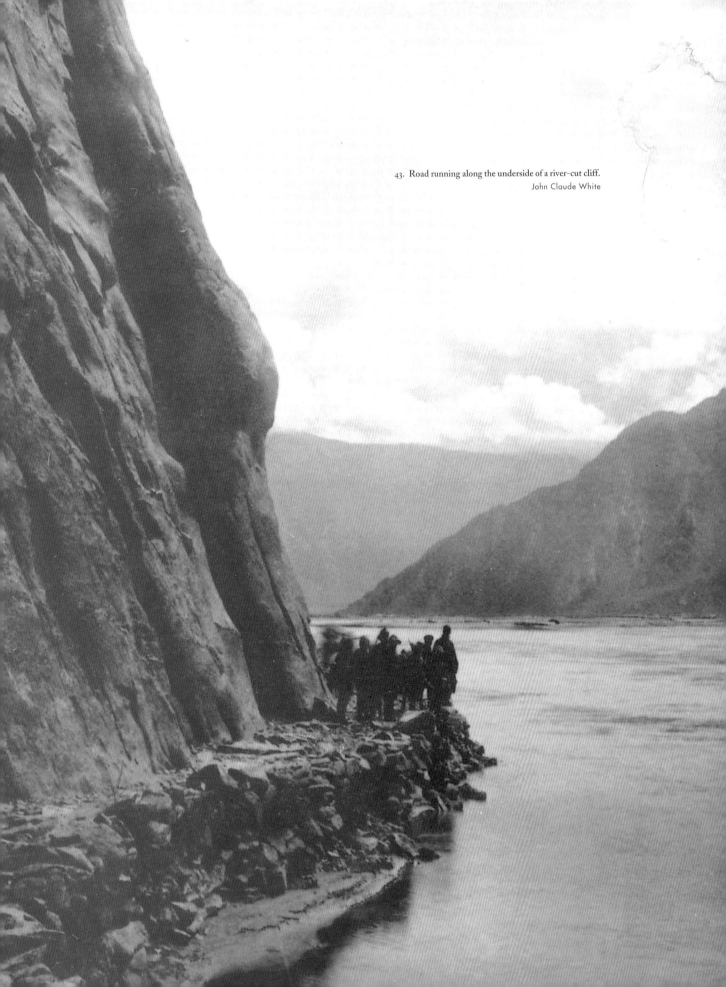

43. Road running along the underside of a river-cut cliff.
John Claude White

44. Couriers changing over at a postal station on the Gyantse to Lhasa road.
The most urgent messages or letters were written on red cloth and wrapped
around an arrow. Such *da yig* or arrow letters entitled the runners to horses,
enabling longer distances to be covered at speed.
Charles Bell

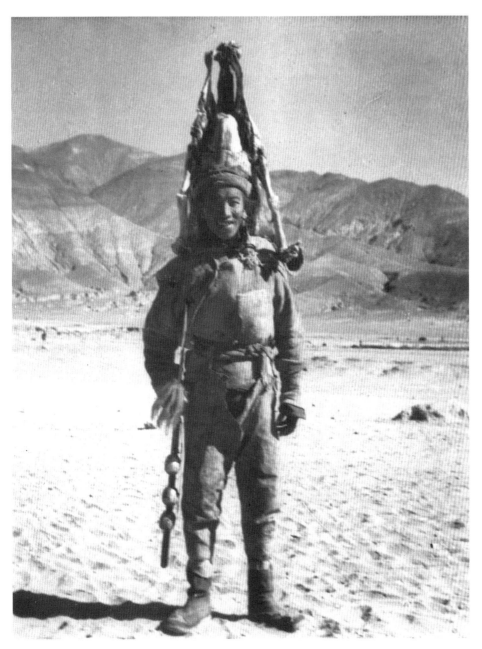

45. Postal runner carrying the Tibetan government mail between Gyantse and Gobshi.
Runners were local people providing the service as part of their tax. Mail was carried in 4-mile
relays and a number of postal stations existed on the main routes (see opposite). Each runner
carried letters in a cloth bundle over his shoulders. The spear was a defence against wild
animals and robbers while the bells at the top let people know the courier was coming.
Charles Bell

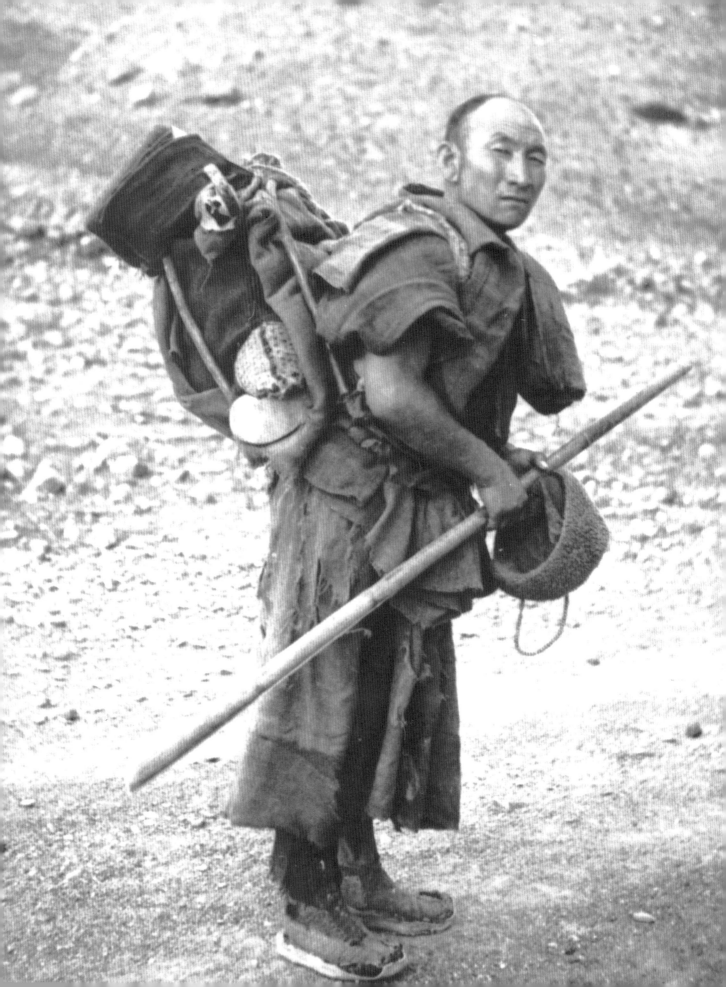

46. A Mongolian pilgrim between Gyantse and Gobshi on his way to Lhasa.
As Mongolia had been evangelized by the Geluk order, a steady stream of
Mongolian pilgrims converged on the Gelukpa temples and monasteries of
central Tibet. Mongolian merchants and pilgrims would join others from Amdo
near Lake Kokonor (on the north-eastern border of Tibet) to travel to Lhasa
together for protection from armed robbers. Such caravans came twice yearly.
Charles Bell

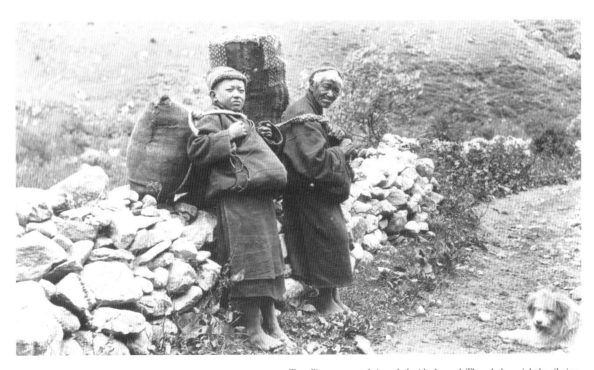

47. Travelling nuns rest their packs beside the road. Though they might be pilgrims,
it was also common to see nuns travelling on visits between their nunneries
and their family homes. It has been estimated that there were over 600
nunneries in Tibet, although most had fewer than 100 women in residence.
Charles Bell

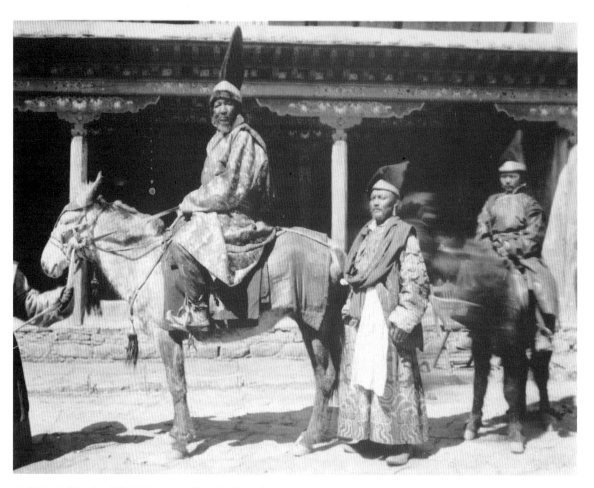

48. The head of the triennial Ladakhi mission to Lhasa (the Lopchak) and
his son on horseback. The Lopchak had been established in a treaty between
Lhasa and Ladakh dating from the end of the seventeenth century. This provided
for a mission combining trade and tribute that would travel to Lhasa every three years,
taking with them gifts for the Dalai Lama. These offerings were specified as
a certain amount of gold, saffron and cloth. By the twentieth century the missions
were more or less trading ventures, but of a highly profitable kind as, under the
terms of the original treaty, transport was provided by the people en route as
a form of taxation (*ula*). This meant large profits for the leader of the mission
who returned with 200 animal loads of shawls, wool and tea. In a formalized return,
the Lhasa government sent to Ladakh an annual trade caravan of 200 animal loads of tea
(the Chapa or tea caravan).
Charles Bell

49. Monk traders working for their monastery return from Gyantse with incense sticks. They were photographed at Shigatse. Monasteries were amongst the greatest traders in Tibet, drawing off their often large surpluses of agricultural produce, collected as rent from their tenants, to mount trading expeditions. The incense sticks not required by the monastery itself would have been traded on for profit. Money from trading was used for the upkeep of or repairs to buildings, to finance new construction, for rituals or for the making of religious images.
Charles Bell

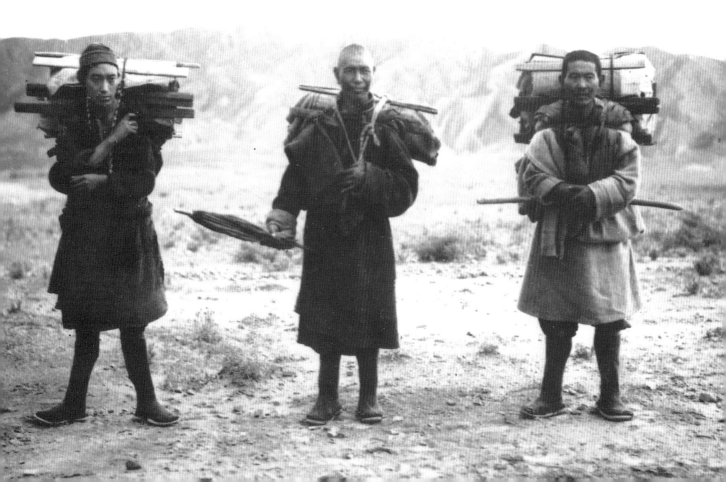

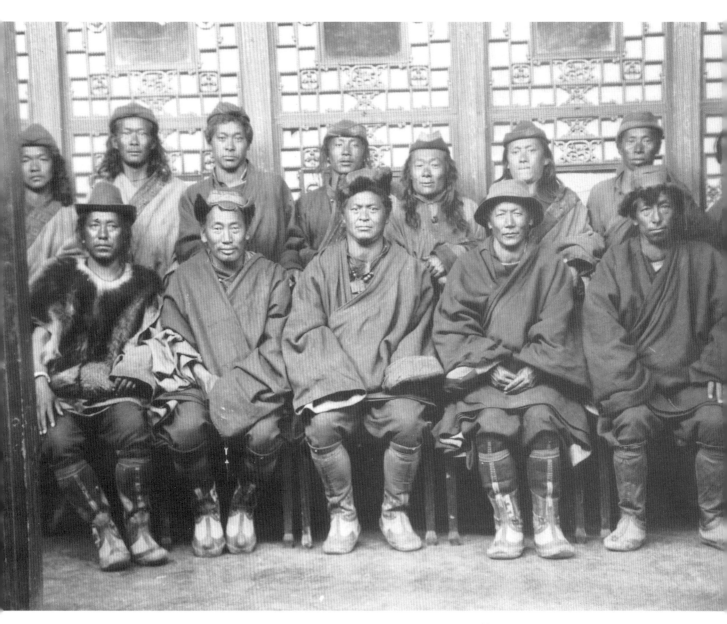

50. Posed group of men from the Po region of south-east Tibet, where the men,
as in other areas of Kham, had a reputation for toughness and largeness of frame.
The Po area was also well known for its craftwork. With an abundant supply of
wood there were excellent carpenters, but metalworking and
basket weaving were also well developed.

Charles Bell

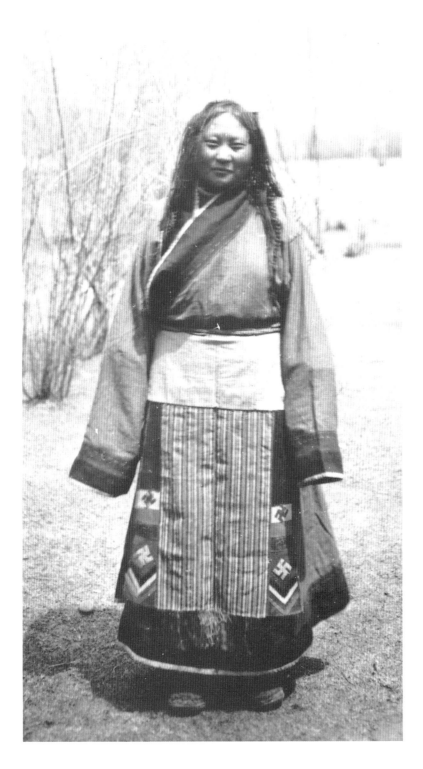

51. A farmer's wife from Derge Horpo in eastern Tibet, perhaps visiting Lhasa as a pilgrim. Her apron includes swastika designs. This ancient Indian symbol of endlessness and continuity is not uncommon in the Tibetan arts.
Charles Bell

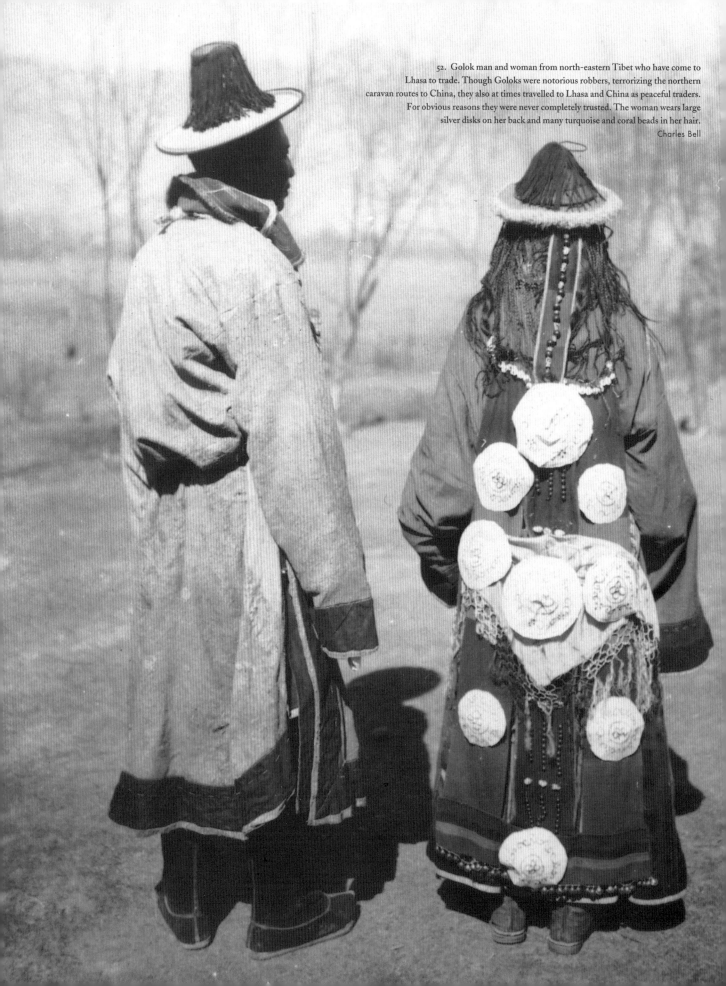

52. Golok man and woman from north-eastern Tibet who have come to Lhasa to trade. Though Goloks were notorious robbers, terrorizing the northern caravan routes to China, they also at times travelled to Lhasa and China as peaceful traders. For obvious reasons they were never completely trusted. The woman wears large silver disks on her back and many turquoise and coral beads in her hair.

Charles Bell

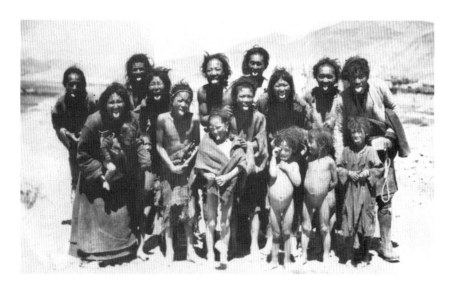

53. Beggars, encamped between Gyantse and Gobshi, give the usual greetings of respect to a social superior by sticking out their tongues and sucking in their breath sharply. Putting one's thumb up was also part of the greeting.
Charles Bell

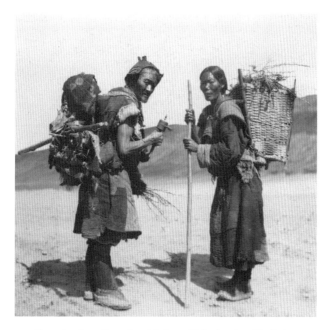

54. Unemployed travellers, who might be combining begging with pilgrimage. Thorn has been gathered to make a fire later in the day, but the journey continues while the man ceaselessly turns his prayer-wheel. The over-clothes (*chupa*) of poor people like these were shorter than those of higher social groupings.
Charles Bell

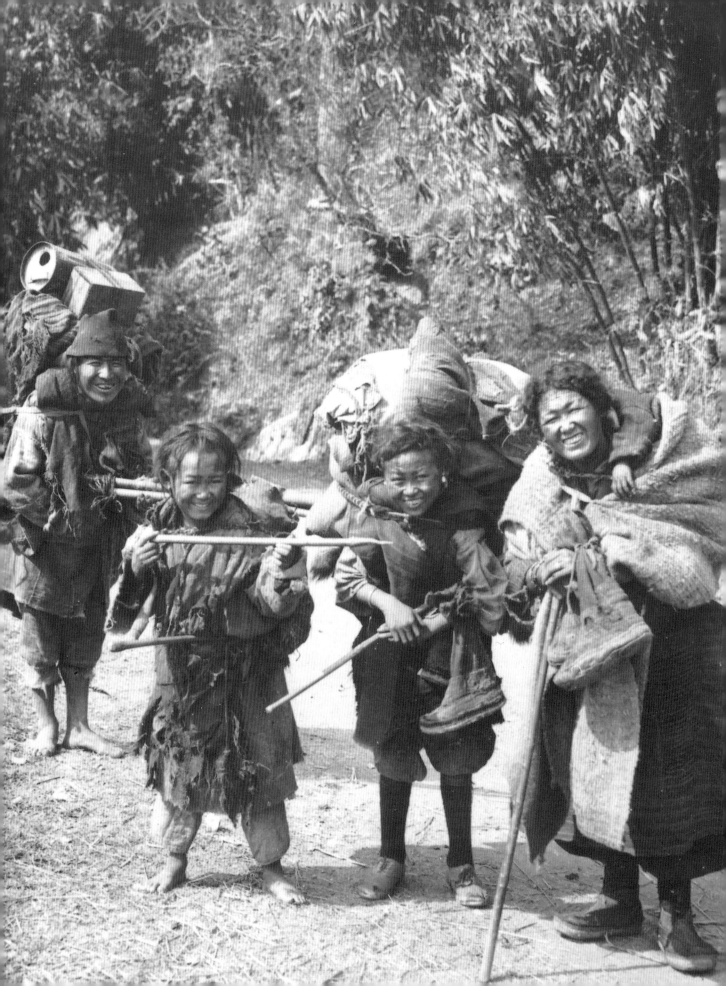

Left
55. Four beggars carrying their possessions: bedding, cooking pots, cotton tents and bamboo tent-poles. They are returning to Tibet from Kalimpong in West Bengal, which they have just left. It was usual for beggars to travel in family groups, and northern India was a favourite destination in the winter months. They often sang, danced and played the fiddle to earn money on the way. As the pre-eminent place of pilgrimage, with a large floating population, Lhasa also attracted beggars in huge numbers.
Charles Bell

56. Like this man, most travelling dance performers (*ralpas*) werc from eastern Tibet. Note the hanging tassels at his waist. Bell wrote: 'he turns somersaults forwards and backwards with the sword in this position'.
Charles Bell

57. Chief of a group of beggars playing a lute or *dranyen* near Dzara. Beggars would often dance while one played an instrument. This man's hat suggests that he is from the western border regions of Tibet.
Charles Bell

Craft, Art and Architecture

In Tibet virtually all the material objects of life, in addition to much of the religious art of the country, were made by craftsmen working with simple, locally made tools in workshops near or in their homes. By 1950 there were only two semi-industrial factories in Tibet, the mint and arsenal in Lhasa.

There were large numbers of farmers who practised craftwork in their spare time, particularly in the winter months when there was little agricultural work. These included part-time carpenters, tanners, tailors, weavers, shoemakers and metalworkers. Some of these, such as the weavers, shoemakers and tanners, also produced the raw materials they needed from their own flocks and herds. Full-time specialist craftsmen, who produced woodwork, metalwork and paintings, were found in settlements near to large monasteries or in towns at the juncture of major trade routes where work was plentiful. It was they who produced the scroll paintings (*thangkas*) depicting Buddhist deities which hung in the private chapels of houses and the assembly halls of monasteries (see figures 17 and 58). The monks themselves practised the painting of *thangka*s and murals, and the modelling of dance-masks (see figure 108) and clay statues, but rarely worked in stone or metal. In central Tibet in particular there was a prejudice against metalworkers as they were linked to the making of weapons which took life, hence the craft was seen as unfit for religious people. Monks were often excellent tailors, specializing in the manufacture and repair of the large appliqué or embroidered hangings displayed at festivals (see figures 75 and 135), and were responsible for the printing of the sacred scriptures. Both monks and lay workers made the printing blocks necessary for this process, a laborious task involving the cutting away of the wood surrounding the letters (see figure 59).

In Lhasa, the central government ran a workshop at the foot of the Potala (see figure 158) in which metalwork of all kinds, including the casting of images, was carried out by around 150 craftsmen. Other government craftsmen in Lhasa included *thangka* painters, shoemakers, tailors, masons and carpenters. These craftsmen were responsible for supplying all the domestic and religious objects needed by the large monasteries surrounding Lhasa. Foreign craftsmen, particularly from China and Nepal, were important in Tibet. In central and southern Tibet, Newars from Nepal were among the best gold, silver and copper smiths and made jewellery, utensils and ritual

objects. In the nineteenth century and earlier they specialized in crafting the splendid copper-gilded roofs crowning the most important monastic buildings (see figures 9 and 77).

The spinning of wool and the weaving of woollen cloth went on throughout central and southern Tibet, but the making of carpets was centred mainly in southern Tibet (see figures 70, 71 and 72), though cloth was also made in central Tibet. Production was at a village level for home consumption, but large estates also had their own workshops. Small-scale commercial carpet 'factories' employing fewer than 30 weavers, spinners and dyers also existed in larger southern Tibetan towns. Tibet resembled medieval Europe in making no special distinction between what we see as the 'fine arts' of painting and sculpture and 'crafts'

58. A line of religious images in metal: the Buddha Sakyamuni (left), the eminent lamas (centre) and two bodhisattvas (far right). They stand beneath hanging scroll paintings (*thangkas*) in the Zhelye Tse chapel of the Palkhor Chode monastery in Gyantse. Religious images of whatever type were mainly commissioned for the purpose of creating religious merit. Usually this was dedicated to a specific purpose, such as the overcoming of obstacles or other negative occurrences like illness, in the lives of the patron or his family. They were also ordered to help individuals at times of transition, for example after death, to increase the likelihood of a good rebirth. Images were frequently offered to monasteries as meritorious gifts. The blessings created by religious icons were felt to affect not only the commissioner, the maker and the person for whom they had been made, but to create a force which spread outwards affecting all beings.
Charles Bell

such as weaving or woodcarving. While the Tibetans have a fine aesthetic sense there was never a large gap between the craftsman and the artist, they were virtually one and the same, and originality was not sought. In fact, for religious reasons, the opposite quality of adherence to former models was central to the Tibetan arts. Paintings and statues were not considered effective in holding the power of the deity they represented unless they followed the proportions and iconography laid down in scripture.

Both the form of Tibet's architecture and the materials used related strongly to its climate and landscape. Houses and temples were constructed of stone or compressed earth built up inside wooden shuttering. Larger buildings had the characteristic battered shape caused by thicker base walls which tapered upwards to give greater stability. Roofs were flat, made of tamped earth over brushwood laid on rafters. The wooden frames of doors and window lintels were also carved and painted to varying extents depending on the importance of the building. Wall surfaces around windows and doors had painted surrounds splayed to match the lines of the main walls, and curtains of coloured material fringed the tops of windows. As in a number of ancient civilizations, to which Tibetan architecture is related, Tibetans never learnt the use of the arch or vault. Consequently, the roofs of large halls were supported by multitudes of thick wooden pillars. Older internal woodwork, such as pillars and their characteristic ceiling brackets, is often exquisitely carved and painted in typically brilliant primary

colours (see figures 112 and 118). Only the most important monastic temples, usually the tombs of the Panchen or Dalai Lamas, were finished with the graceful Chinese-style gilded domes (see figure 85).

59. A printing block for sacred scriptures at Narthang monastery in central Tibet, with more blocks stored on shelves behind. Each block, forming an individual page, had to be laboriously created by the cutting away of wood surrounding the letters. A printed page from another edition was first pasted down as a guide. An average-size block, like the one shown, measuring thirty by seven inches, could take from seven to ten days to make. As the first of the two sections of Buddhist scripture, the Kangyur, consists of 108 volumes, the numbers of blocks ran into thousands. Narthang was one of the most important printing centres, having blocks for the first codified edition of the whole canon of Buddhist scriptures. When a copy of a book was to be made, the patron was expected to supply the paper and the monks, working in teams, did the printing.
Charles Bell

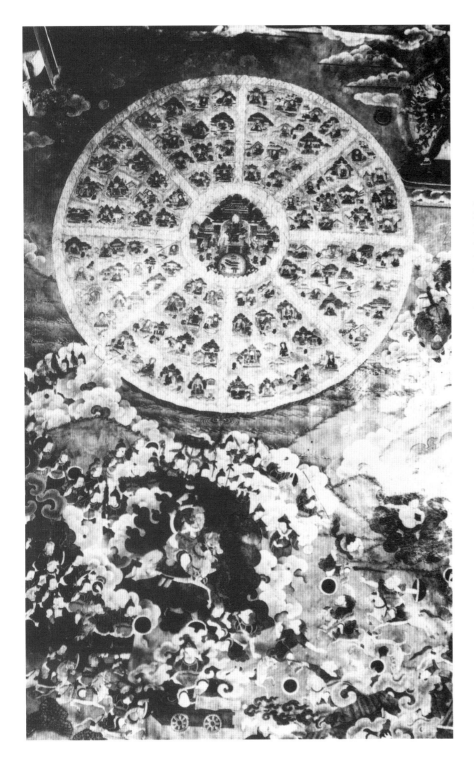

60. Wall-painting in the Lhasa house of the wealthy nobleman Lhalu. It depicts the prophecy of Shambala and the end of the world. The mythical kingdom of Shambala is situated somewhere in the north, separated from the known world by the river Sita and surrounded by a double row of snow mountains. The prophecy relates that the world will be conquered by Muslim armies from the west, but that Rudrachakrin, the King of Shambala, will ride out with his forces and defeat them. This will allow the Buddhist teachings to spread throughout the world, inaugurating a new golden age. Rudrachakrin is the larger figure seen charging with his soldiers from the bottom left. The legend of a hidden land guarding a spiritual culture amidst a hostile world was reinterpreted for a popular audience by James Hilton in *Lost Horizon*.
Charles Bell

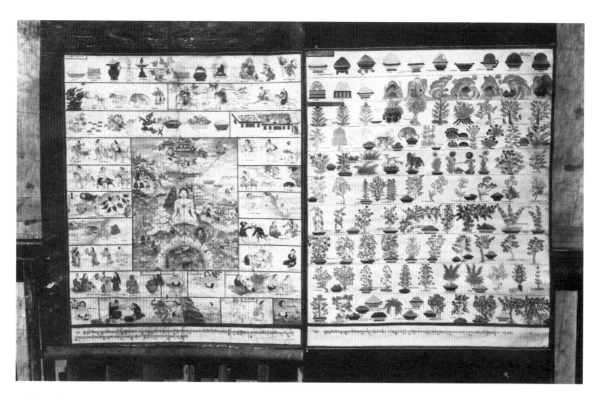

61. Two medical paintings in a dispensary in Lhasa showing, on the left, omens and dreams seen by a doctor or patient and, on the right, herbs and substances used in medicines. The two rows at the top of the painting on the left show good omens, below and on the right are bad omens. The lines that radiate from the central figure represent possible paths of dream conciousness, which creates dreams as it moves outwards from the energy centre at the heart, the seat of the subconcious mind. The differing dreams created help diagnose which energy predominates within the body. Medical *thangkas* (scroll paintings) provided teaching aids in the medical institutes, or, as in this context, were used during consultations with patients.
Charles Bell

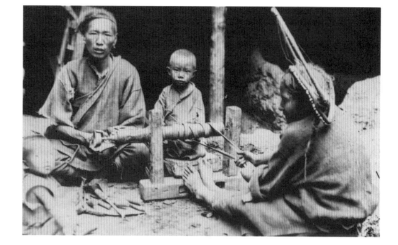

62. A Tibetan metalworker in central Tibet polishes a cast butter-lamp with a strap lathe. The lathe is operated by his wife who pulls the strap manually. Almost all the more important towns of central Tibet had their metalworkers, though Lhasa had the largest number and was known for its fine jewellery.
Charles Bell

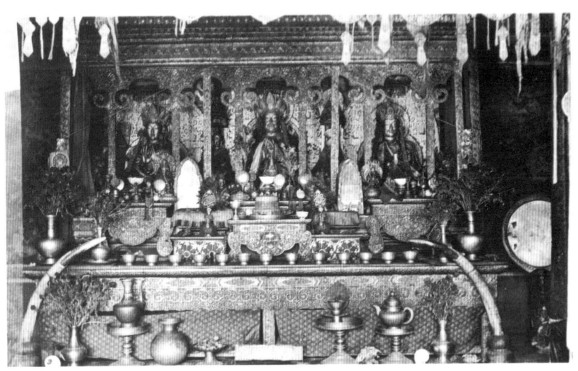

63. Altar showing offerings arranged on tiered stands before the main images of deities. These honour and please the gods, drawing them near. Offerings of light, water, food, incense and flowers are always found on a Tibetan altar. Of these, light and water are the two most important. The row of bowls (always at least seven, and sometimes more) on the second shelf up would contain fresh water; butter-lamps giving light are below and out of this particular photograph. Several of the other offerings are found elsewhere and each of these also has a number of inner meanings; a lit butter-lamp, for example, symbolically dispels the darkness of ignorance. Anything precious or unusual, such as the elephant tusks (bottom right and left), was placed on an altar.

From Bell's archive, possibly by David Macdonald

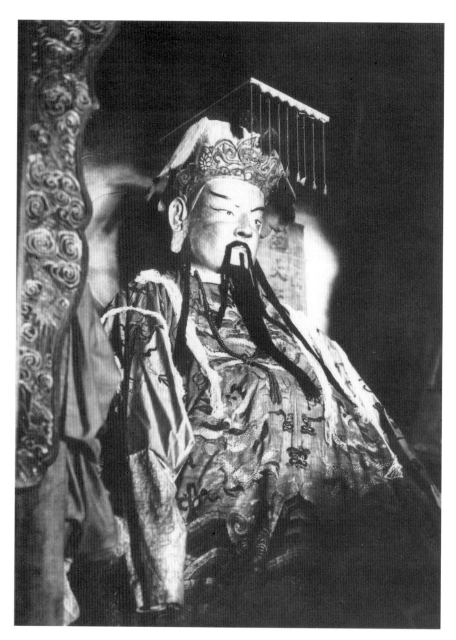

64. Statue of King Gesar, the legendary divine hero of ancient Tibet, in the Gesar
temple at Shigatse. The epic story of Gesar of Ling, who having been sent from
heaven to restore order on the earth, spent his life vanquishing demons and
conquering kingdoms, was sung by professional singers or bards. Some of these
could recite the story for seven days without repeating themselves. Popular all over
Tibet, it is also known in written versions.

Charles Bell

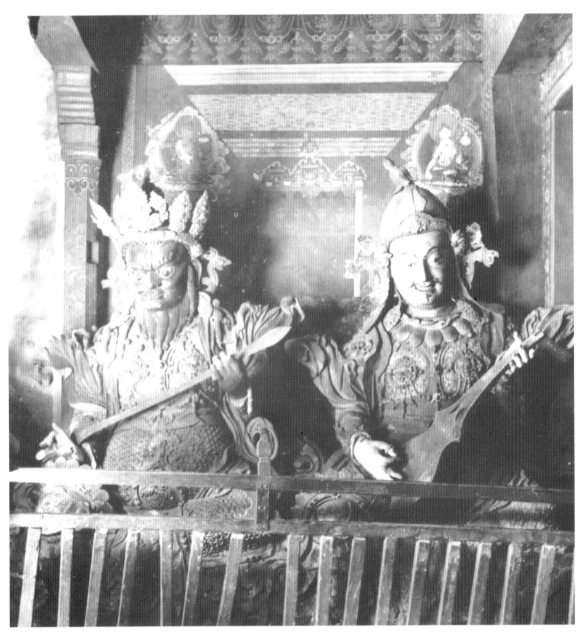

65. Clay images of two of the four Guardian Kings typically found each side of the entrance to Tibetan temples. These figures guard the four directions in Buddhism and are conceived of as dwelling on the slopes of the world mountain (Sumeru). On the left, holding a sword, is Virudhaka, guardian of the south; on the right, playing a lute or *dranyen*, is Dhritarastra, guardian of the east.

Charles Bell

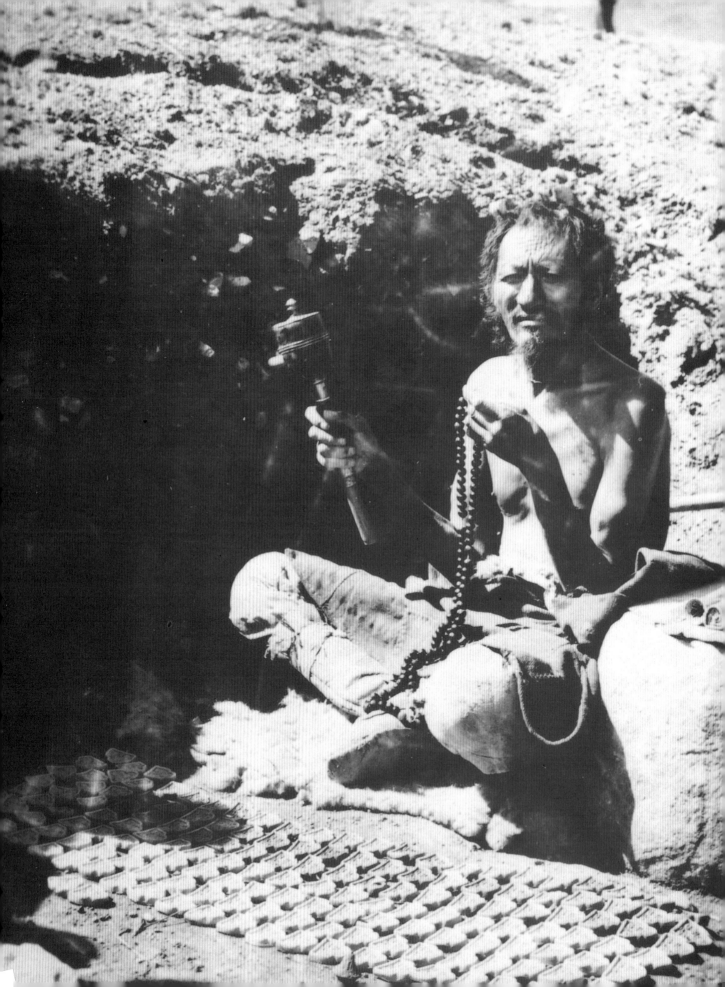

Left

66. Small images of deities and *chorten* (*tsa tsa*) are drying after being created by pressing metal dies into wet clay. When dry, these *tsa tsa* are sold outside temples to take away or to offer inside.
Charles Bell

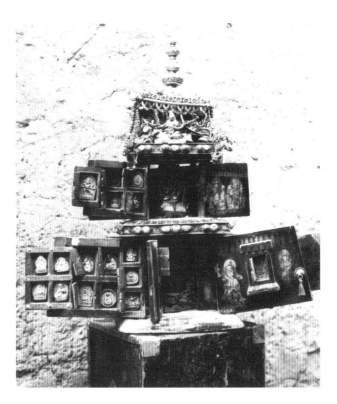

67. Storytellers, called *lama mani* or *manipa*, wandered through Tibet reciting the life stories of saints. The small clay-stamped images (*tsa tsa*) were visual aids that could be pointed to during recitation, each revealed behind a small door. The shrine is a miniature *tashigomang* or 'many doors' *chorten*, a form which can also be seen on a larger, architectural scale (see figures 77 and 120).
Charles Bell

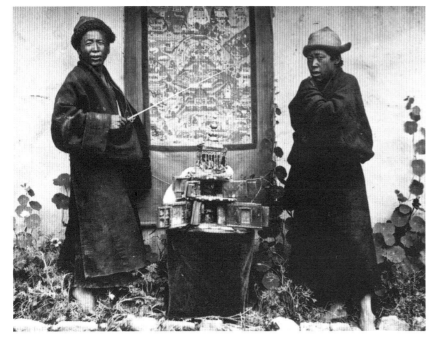

68. Two itinerant storytellers with portable shrine and scroll painting (*thangka*). The lives of favourite yogis and saints, such as Padmasambhava or Milarepa, would be recited while the events referred to were pointed out in the painting.
Charles Bell

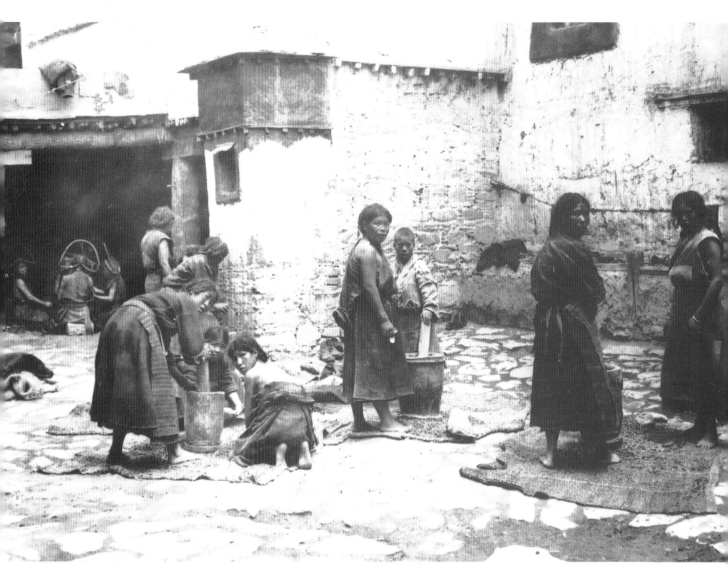

69. Women at Penjor Lhunpo grinding *tso* or madder roots to make the
characteristic dark red dye used for colouring yarn. The plant grows in parts of
southern Tibet and the Himalayas.
Charles Bell

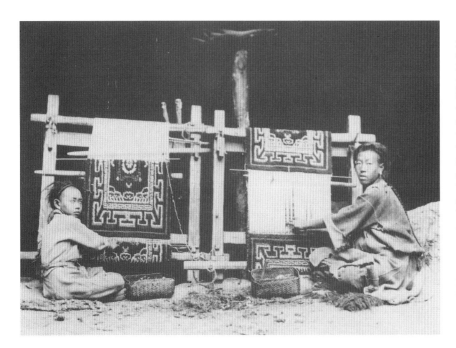

70. Woman and child weaving rugs on typical upright carpet looms. Such small rectangles were probably intended for use as individual seats. The warp is wound in a continuous loop around the upright frames. Until the 1930s traditional vegetable dyes were still frequently used. The most common were madder or lac for reds, indigo (from India) for blues, walnut for browns and the rhubarb root, barberry or buckwheat for yellows. The border of T-shaped double-key meanders and the stylized mountains and seas within the square field are Chinese-derived elements typically found on Tibetan rugs.
Charles Bell

71. Woman weaving woollen cloth on a horizontal frame loom, operated by foot treadles. The warp is wound around rods laid parallel to the ground and the weft inserted by means of a bobbin. This type of loom, used mainly for cloth weaving in Tibet, was introduced into Bhutan in the 1930s where it is still in use.
Charles Bell

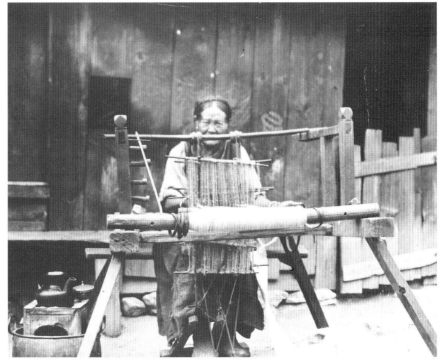

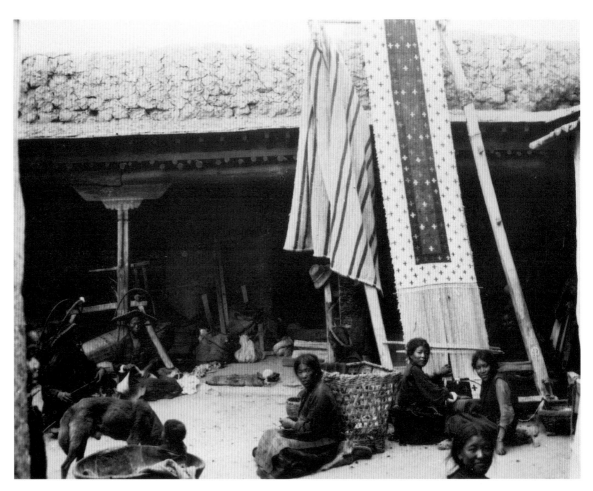

72. Woman weaving a carpet on the verandah of the first floor of Penjor Lhunpo. The unusually tall, 15-foot-high loom, was built to allow the weaving of runners (*kyongden*). These were mainly used in monasteries to cover the continuous seating of monks sitting in rows on either side of an aisle (see figure 112). Carpets in Tibet were most often used for sitting and sleeping on, and rarely as a floor covering. The design of contrasting crosses is a popular textile pattern also found on felt and tie-dyed woollen fabrics.

Charles Bell

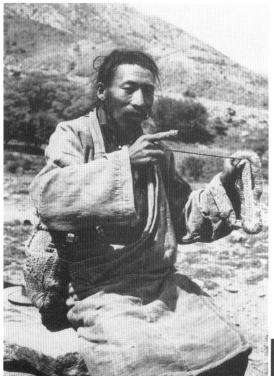

73. A servant at Rinchen Ling making a boot for himself. Boots had high woollen or felt sides and flat soles of yak hide. Here, he stitches the side of the boot with woollen thread. On his forefinger is a wooden thimble. The clothes of the lower social groups were usually home-made, often from their own wool. This man wears the long, coat-like *chupa* worn by both men and women in Tibet, the men also wearing trousers underneath. A large pocket created by tying it at the waist was used to hold a wooden cup and any other small items.
Charles Bell

74. A noble family's tenants would spin and weave cloth on the estate for their lord. Here at Penjor Lhunpo, at Dongtse, women fold up woollen cloth into bundles. Cloth not needed for the clothes of servants would be sold to traders or neighbours.
Charles Bell

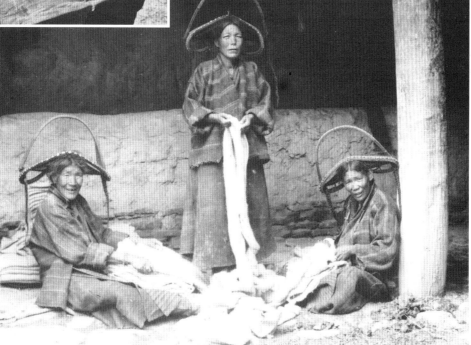

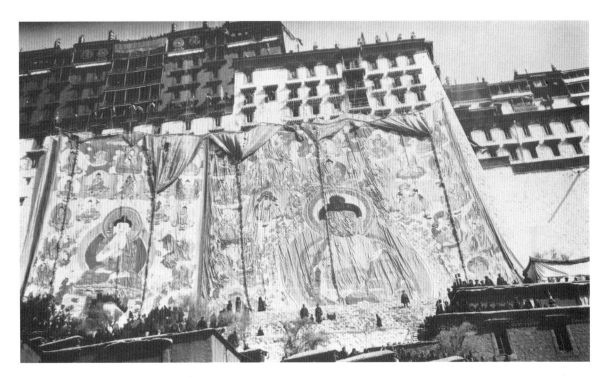

75. The giant silk hanging (*Koku*) hoisted for the Sertreng festival. Depicting the present and coming Buddhas, the *Koku* was made of two silk appliqué panels about 75 by 40 feet in size. Once hoisted, the Cabinet (Kashag), monk officers and onlookers publicly revered it.
Charles Bell

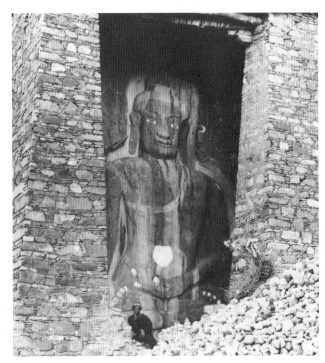

76. Large Buddha Sakyamuni carved in a cliff at Nyethang, 25 miles west of Lhasa. The painted relief is protected by its own building, roofed but open at the front. Nyethang is the site of a monastery founded by Atisha (see p. 12), who died there in 1054.
Charles Bell

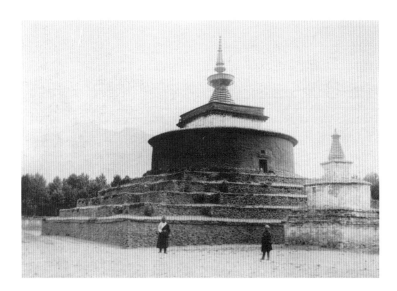

77 Large *chorten* of the *tashigomang* or 'many doors' type at Tshe Gungthang monastery, fifteen miles east of Lhasa. Dating from the twelfth or thirteenth century, it is an earlier forerunner of the famous Gyantse Kumbum (see figure 120). Bell recorded that it also contained many Buddha images. *Chorten*s can function as reliquaries, holding the ashes of important religious or secular figures, but they are primarily religious structures symbolizing the Enlightened mind of the Buddha.
Charles Bell

78. View of Tashilunpho monastery showing the funerary chapel of the First Panchen Lama, at left. Founded in 1447 by Gedun Drup, the nephew of Tsongkhapa and the First Dalai Lama (retrospectively designated), it became the seat of the Panchen Lamas.
Charles Bell

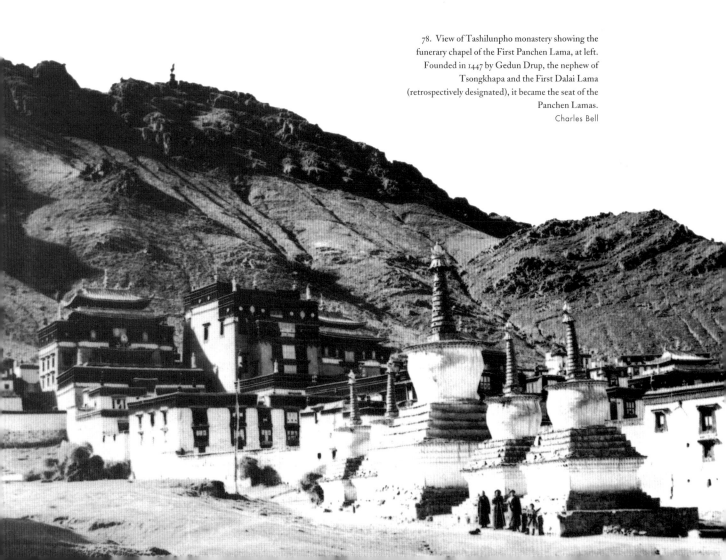

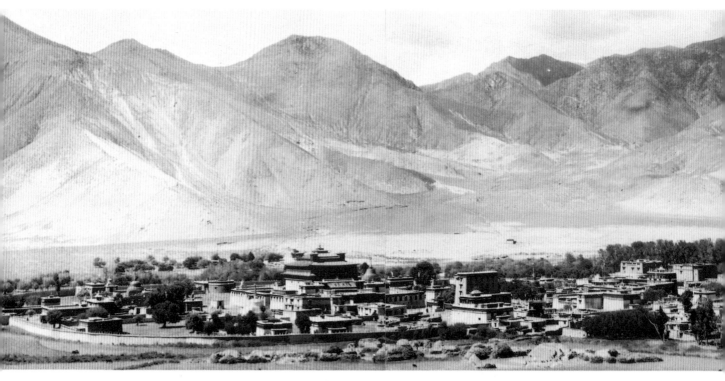

79. Samye, the first monastery built in Tibet (during the 770s CE) and copying in layout the great Odantapura monastery in northern India. Mandalic in form, it replicates the Buddhist conception of the universe with a central temple representing Mount Sumeru, the mountain at the centre of the cosmos. Four large *lings* or temples at each point of the compass represent the four world continents, one of which is the human world. Tiny *chortens* running along the top of the encircling wall can just be seen, while four larger ones inside signify the four directions. Another two temples represent the sun and moon.

Charles Bell

80. Like small towns, monasteries had narrow streets that ran between the complexes of houses which faced inwards towards central courtyards. This street is at Nechung, the monastery of the State Oracle.

John Claude White

81. A street in Dechen village. The houses are made of local stamped earth or stone, with flat roofs on which fodder, drying hay and firewood are stored. Houses are built around a central courtyard. Animals and fodder are kept on the ground floor. On the floors above are the kitchen, bedrooms, chapel (which also doubles as a guestroom) and any other storage rooms needed. Furniture is sparse and consists of low wooden tables, straw-filled mattresses for sitting or sleeping on and chests standing against the walls. There was very little glass in Tibet and most houses had windows covered with white cloth to keep draughts out and let some light in.

Charles Bell

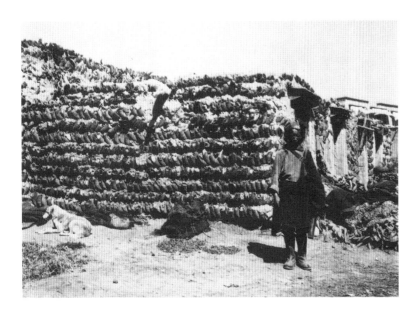

82. Houses of the *ragyapas*, the scavenger beggars of Lhasa whose main duties were the disposal of the dead in the city. Bodies were carried bundled up on their backs to the place outside the city where the rite of 'sky burial' was carried out (see figure 93). They also carried dead animals out of the city and pursued criminals. Though their unsavoury occupation made them outcasts, living in hovels off the Lingkor, well away from the centre, some managed to become quite wealthy. Their houses were of turf or mud, into the fronts of which they pressed the horns of cattle, yaks and sheep.
Charles Bell

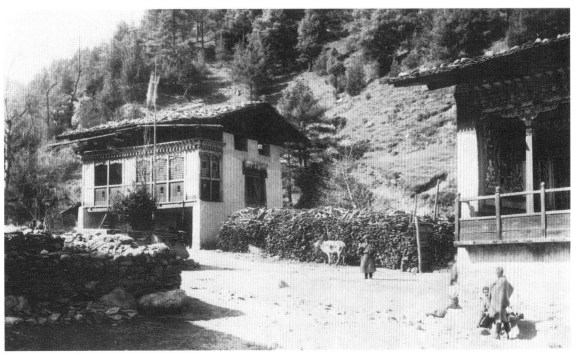

83. Bell commented on the good quality of the houses of the Chumbi Valley with their richly decorated private chapels, the result of a buoyant economy based on through trade (see figure 28). Stables on the ground floor had two living floors above them. The carved woodwork and overhanging roofs of pine shingles, weighted with stones, remind one of Bhutanese houses or Swiss chalets.
John Claude White

Tibetan Religion

Though monastic Buddhism is often considered synonymous with Tibetan religion, a pre-Buddhist animistic faith in the spirits of the earth, waters and sky has remained a strong force since early times. As they developed, the monastic orders found ways of accommodating elements of the ancient beliefs, involving exorcism and divination, into their belief structure. This was particularly true of the Nyingmas (the 'Old Ones'), a sect with a core of teachings dating from the monarchic period and the centuries immediately following it (see p. 11). However, even the reformed order, the Gelukpas, followed the pre-Buddhist practice of consulting oracles, with the central government taking advice from the Nechung State Oracle. Monks from the large monasteries would also perform rituals in the fields to prevent frost or to bring rain. But the relationship of the old beliefs to Buddhism is seen most clearly in the manner in which a number of pre-Buddhist demons or nature spirits were transformed at an early date into guardians of Buddhism. This process is often described literally as that of the taming of demons by famous Buddhist saints such as Padmasambhava. The new guardians, though seen as powerful in the lower worlds such as ours, were always recognized as ultimately subordinate to the Buddhist deities.

For Tibetans a host of spirits inhabit the rivers, lakes, mountains and sky. Sickness, misfortune or even death can follow if these spirit forces are offended through activities such as digging in the earth (for minerals), obstructing or polluting a watercourse or constructing a building. Offerings are therefore always made before undertaking any activity that might disturb them. In the case of illnesses thought to be the result of demonic attack, model effigies painted on wooden strips are offered as ransoms to the spirits in place of the victim. The offering of effigies or decorated dough cakes (*torma*s) to deities also reflects the ancient animal or human sacrifice of pre-Buddhist Tibetan religion. Specialist magical operations, particularly for controlling hostile spirit forces, were carried out by a class of wandering magicians called *nagpa*s (see figures 21 and 91). Though many of these beliefs were accommodated within Buddhism they also form a separate religion called Bon.

Bon is not simply the pre-Buddhist religion but represents a blend of animistic beliefs with Buddhist doctrines such as karma and rebirth. During its development Bon appropriated much of the iconography and ritual of Buddhism. Like Buddhism, Bon now has a monastic organization (see right) and many of its deities are clearly

borrowed from Buddhism. In its development Bon also absorbed elements of Chan Buddhism, the Chinese Buddhism that became Zen in Japan.

Folk Religion

The folk religion of Tibet is the body of beliefs and practices of the layman, which relies more on handed-down traditions than on monastic or textual authority. The generation of religious merit, which cancels out the effect of past sins, thus ensuring better rebirths, is of the greatest importance to Tibetans. Among the ways merit may be gathered is by the recitation of mantras, short formalized prayers invoking a deity, which are often said while turning a prayer-wheel, which itself sends out prayers. Walking around religious buildings such as *chorten* (which represent the Buddha's Enlightenment, see figure 78) or temples is another devotional act that generates merit and is often performed while reciting mantras. Worship is carried out by most families at their own altars where fresh water is offered every morning and butter-lamps lit in the evening (see figure 63). Spiritual protection from forces that could cause illness, death or other misfortunes and the seeking of material and spiritual blessings is approached through prayer to the gods and by acts of personal piety. Protection and blessings are also sought with the assistance of the Buddhist gods at monastic ceremonies, through the reading of scripture at one's house (see figure 91) or by commissioning new images of the gods. For protection on a smaller scale, amulet boxes containing holy objects are worn by

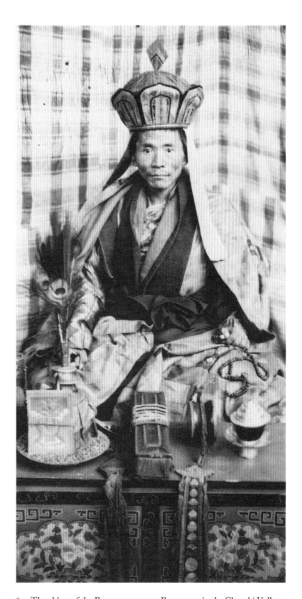

84. The abbot of the Bon monastery at Pumogang in the Chumbi Valley. Bon incorporated elements of the early pre-Buddhist religion of Tibet, but adapted for its own needs much of the iconography and outward trappings of Buddhism. For example, the abbot here wears a hat (of Chinese silk) loosely based on the Five Buddha Crown of Buddhism. His other religious objects – to his left a table prayer-wheel, a ritual water vessel with peacock feathers in its top, a book of scripture and a hand drum – might equally be found before a Buddhist monk. The covered raised cup is for tea, taken at intervals throughout ceremonies in Tibet. Charles Bell

both men and women. The holy objects inside ward off evil forces which might threaten the wearer. At the same time Tibetans never forget to propitiate the pre-Buddhist demons and spirits of the house, land, waters and sky (see figure 90).

Nearly all Tibetans went on pilgrimage at some stage during their lifetime, and such journeys were among the most important ways of gathering merit. There were places of geomantic power throughout Tibet, whose holiness was enhanced by legend or association with saints. These included mountains like Mount Kailash, sacred to both Buddhism and Bon, or, on a smaller scale, the cave of Milarepa near Nyelam on the border. Monasteries associated with important religious figures also became places of pilgrimage, like Tashilhunpo (see figures 77 and 85), the residence of the Panchen Lamas. Above all Lhasa, home of the Dalai Lama and with its ancient and most holy shrines including the Jokhang, the first temple built in Tibet, was the goal of pilgrims who journeyed from as far away as Siberia, Mongolia (see figure 46) or the borders of India. As pilgrimages were often made on foot and might take in a number of sacred sites, they sometimes lasted years. The merit derived from a pilgrimage was frequently increased by other practices: for example, large stones might be carried around mountains or prostrations might be performed throughout the whole journey (see figures 96 and 97).

Tibetan Buddhism

Tibetan Buddhism is the result of centuries of growth from the seed planted by its founder, Siddhartha Gautama, who lived in northern India between 563–483 BCE. The core beliefs of Buddhism, encoded in the 'Four Noble Truths', taught by Buddha in his first sermon, are the foundation on which all the later complex of doctrine rests. The first truth says that the process of life inevitably involves suffering: not to gain what you most want is suffering, to have what is loved taken from you is suffering, birth, illness, old age and death are suffering. The second truth analyses the cause of suffering as grasping or desire, which inexorably leads to reincarnated existence in countless lives in the world, a process governed by karma, the law of spiritual cause and effect. The formation of the ego is an integral part of this, as if in the statement 'I want' the want irresistibly gives rise to the I. There is, however, a state of perfect peace beyond suffering, called Nirvana, which is reached through the letting go of desires. This is the third truth which leads to the fourth, a description of the way life should be lived in order to achieve Nirvana. The early Buddhist ideal was that of the practitioners who strove for their own liberation from the wandering in painful existence, or Samsara, by achieving Nirvana, the absolute state. The Buddhism that Tibet inherited from India had, however, developed more sophisticated understandings of reality and a different spiritual goal between about the first and the fifth centuries CE. The ideal figure now became that of the bodhisattva, a being highly

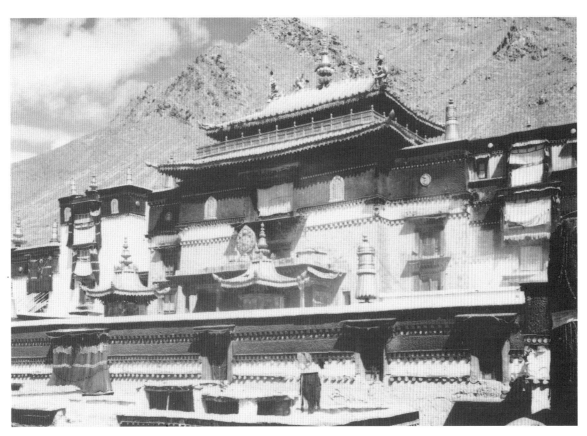

85. The central building with pagoda roofs of gilded copper is the funerary chapel of Lobsang Choki Gyaltsen (1570–1662) at Tashilhunpo monastery. This building houses the *chorten* enclosing his embalmed body. The Fifth Dalai Lama declared Choki Gyaltsen, his tutor, to be an incarnation of the Buddha Amitabha and so began the institution of the Panchen Lamas. Though technically the first Panchen Lama, his three predecessors were counted as incarnations retrospectively, making him the Fourth Panchen Lama.
Charles Bell

evolved enough to merit Buddhahood or Nirvana, but who chose voluntarily to be reborn in the lower worlds to guide all to Buddhahood, vowing not to take that reward until all had been saved. Many of the Buddhist gods were conceived of as such saviour figures who could be worshipped for inspiration and help on the spiritual path or to save one from spiritual or material dangers. Though bodhisattvas were not always conceived of as human, it was nevertheless common in Tibet to recognize a succession of human incarnations as that of a particular bodhisattva. The most famous example of this phenomenon is that of the Dalai Lamas who embody an aspect of the bodhisattva Avalokitesvara. The complex of new beliefs, including the bodhisattva ideal, became known as Mahayana or the 'Great Path', which was regarded by its practitioners as spiritually superior to the earlier ideal, which became known as Hinayana (the 'Lesser Path'). Philosophically, absolute reality was now conceived of as 'emptiness' or the 'void'. In the Buddhist context this does not mean absolute nothingness but is a deep realization that things only exist through their relationship with other things. Because everything is composite and composed of smaller elements, nothing exists in itself as each part depends in turn on its constituent parts for existence. This is true both of the outer world and of the ego itself. But emptiness is not simply a negative way of analysing reality. The recognition of emptiness is blissful because once the fixed idea of an inherently existing self is removed, the root causes of anger and greed are destroyed. Our inate Buddha mind is then freed to

recognize itself, Awakening or becoming Enlightened. Buddhist masters say that our real nature is the infinitive, divine space of emptiness, also described as a self-manifesting luminosity, a light which is all wise and loving. Thus emptiness becomes a dimension of endless possibilities and limitless freedom rather than nothingness.

The worlds in which beings live, including our own, are empty, but, like a dream, have a kind of provisional reality. Ultimately they are just a temporary transformation of emptiness which, like a matrix, underlies all phenomena, out of which all phenomena come and back into which they go. The 'dream state' as a symbol of human consciousness is appropriate in perceptual terms as the dream-world exhibits many of the same qualities as our 'waking state' does to us. In a dream there is the same conviction of existing in a real outer environment that we have in the 'waking state'. In a dream we similarly meet and talk with others who appear as separate individuals; we accept the dream state as normal consciousness while asleep and are unable to conceive what waking up might mean. The senses of sight, hearing, touch, smell and taste are our touchstones of reality and yet when we dream they are duplicated by dream senses that give an equally convincing sensation of reality. It is only when we awake that we realize that the whole dream has taken place within us. Then all the people we have met, the scenery we have looked at, the weather we have experienced all suddenly appear illusory; we realize that they were happening in our mind, they were part of us, and not external to us, all along. One of the meanings of the Buddha's name, *Sange*

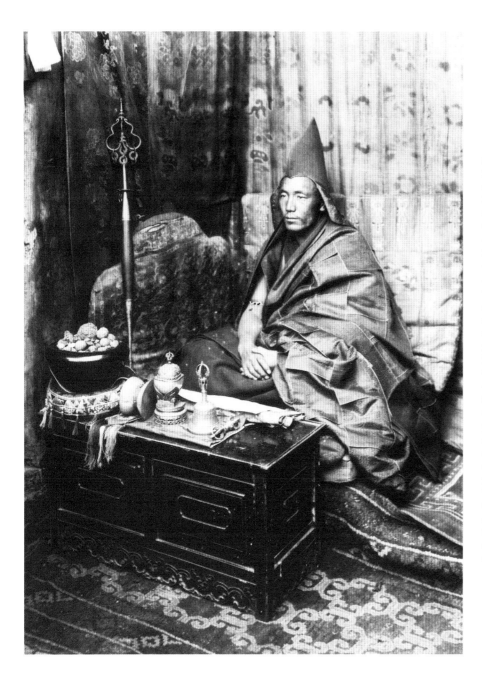

86. Gelukpa incarnation lama (*tulku*) with ritual objects. On the table before him rest a diamond sceptre (*dorje*) and a bell (*drilbu*) – which together symbolize the two primary qualities of the Enlightened state (see p. 84) – a bowl with fruits, a skull-drum and a skull-cup. The use of human bones as musical instruments and ritual offering vessels was adopted from the practices of yogis in medieval India and imported with the Buddhist tantras they practised. Their use goes back to cults involving rituals in cemeteries, the traditional place for the ascetic to confront the impermanence of life and overcome the opposites of pleasure and pain, the clean and unclean. The bowl and staff, traditional attributes of the early Buddhist monks, were by this time purely ceremonial in Tibet.
Charles Bell

in Tibetan, is the 'Awakened One'. Buddhas and bodhisattvas point out that there is little difference between our waking world and the dream. In both, what is not real is taken as real, and what is really connected is seen as separate. Like the person who wakes from a dream, the Buddha or bodhisattva has seen through the dualistic division of the world as something outside themselves and of others as separate from them. Just as on waking we tell ourselves that where we had been was illusory, so the Buddhas or bodhisattvas, having awoken to a further degree, understand our world to be illusory. The higher beings, feeling great pity for others still suffering in self-created delusion, point out that it is our desires that bring us back again and again to a world that involves us in suffering. Just as the hopes and fears, the clingings and graspings of our daily life affect the conscious mind, generating dreams of a particular type, so, on the larger scale of a lifetime, our strongest desires, hatreds and fears generate life after reincarnated life in the world.

Just as when we awaken from a dream we feel we have escaped into a larger and freer world where we have more clarity and awareness, so the Buddha's or bodhisattvas' awakening is fuller still and the consciousness more powerful and far-reaching in the understandings it brings. Glimpses of something close to this awareness are experienced during meditative states. In Tibetan Buddhism the essential nature of Enlightenment is characterized as an unbreakable union of two qualities: transcendental wisdom and compassion. The highest wisdom of seeing the true nature of things as empty and illusory inevitably creates

great compassion for those who still believe the world to be real and who, ensnared by this illusion, struggle and fight to gain things which, in essence, do not exist.

Used together, two Tibetan ritual objects, the diamond sceptre (*dorje*) and the bell (*drilbu*), symbolize this indivisible union. The *dorje* represents practical compassion seeking to save others and the *drilbu* the highest wisdom or understanding of reality (see figure 86). With its symbolism of the indestructible awakened state, the *dorje* has given its name to a rapid path to Enlightenment called Vajrayana (the 'Diamond Path', from *vajra*, the Sanskrit for *dorje*), which existed alongside the Mahayana teachings in Tibet. While Mahayana teachings provided much of the basis for orthodox doctrine and ritual in the large monasteries, esoteric Vajrayana practices were also studied. Both teachings, however, have the same ultimate goal – the achievement of Enlightenment for the sake of others. The meditational practices of Vajrayana manipulate perceptions of 'reality' to bring about an understanding of its true nature that leads to awakening even within one lifetime. The deities of Tibetan Buddhism play a special role in esoteric deity yoga. They can be understood as personifying qualities in our own Buddha nature, which is ultimately the only true deity. In deity yoga, one of the main Vajrayana practices, the form of one specially chosen God or Goddess is visualized in accurate detail with their entourage, a process often taking years. During meditation the deity eventually assumes a convincing reality to the meditator. The divine being will be treated as an external agent,

87. The type of dialectical debate between monks shown here was of particular importance in the Geluk order, being used both as a means of study and in examinations. A set of exaggerated hand and body gestures signified the asking of a question, as here where the questioner is about to clap his hands. The questioner might also emphasize the last word by stamping his feet and shouting. The recipient traditionally sits but may then jump up to refute the questioner's thesis or to pose his own question. Debates could go on for hours or even a whole day.

Charles Bell

worshipped and petitioned as that but then dissolved back into the emptiness or void from which it was created. By this process of creation and reabsorption the practitioner achieves a revelation of the illusory, empty and dreamlike nature of phenomena, and thereby achieves awakening.

These meditational practices and realizations represent the heart and, at the same time, the highest level of Tibetan Buddhism. The full realization of such esoteric practices was achieved by only a small number of monks relative to the very large monastic population. There were around 6,000 monasteries in Tibet, with the number of monks estimated at between ten and twenty per cent of the total male population of the country. The three largest monasteries near Lhasa had around 20,000 monks at the beginning of the twentieth century compared to the city population of about the same figure. Within each monastery about half the monks undertook a graded programme of study and worship. In the Gelukpa monasteries this initially consisted of non-tantric canonical literature with an emphasis on the use of logic, dialectics, and disputation (see figure 87), requiring the learning by heart of whole scriptures. As in the monastic universities of India on which they were based, astronomy, astrology, grammar, medicine and crafts were taught in addition to religion. The highest degree of *Geshe*, equivalent to a Doctor of Divinity, usually took twenty years to complete in the Gelukpa monasteries, and it was only after this had been gained by a formal oral examination that tantric studies could be undertaken at one of the two tantric colleges in Lhasa. The life of the serious monk resembled that of a student moving upward from grade to grade with each transition marked by an examination. A general distinction can be made between the Geluk order, where accurate memorization of textual sources and skill in logical disputation were tested, and the other orders, the Nyingma, Kagyu and Sakya, where paranormal abilities acquired through yoga and meditation were the focus of examinations. In these three older orders individual initiations based on oral instruction were more important. Although these older orders differed in their adherence to particular tantric yogic teachings, this ultimately had more to do with differences over the meditational and yogic means to achieve liberation rather than profound disagreements over its nature.

The other half of the monastic population consisted of those who had neither the inclination nor the capability for book learning and corresponded roughly to the lay brethren in a Christian monastery. So great was the intake of the monasteries, with most families sending at least one younger son in to one, that a large section of the monkhood could naturally not turn out to be mystics or scholars. They performed necessary duties such as cooking, cleaning, playing musical instruments, serving tea at ceremonies, craftworking or trading. From them were also drawn the fraternity of more physically inclined policeman or fighting monks, the *dob dob* (see figure 116). Others who were more intelligent became administrative officials or traded on the monasteries' behalf.

88. The mantra or invocation prayer of the eighth-century tantric master Padmasambhava. Formed out of white stones, the letters are probably five or six feet high enabling them to be seen from a distance. Giant prayers like this, or smaller ones carved on stones, were made as acts of piety, bringing merit to those constructing them and blessings to all who saw them. The mantra 'Om ah hum, vajra guru padma siddhi hum' can be translated as 'Oh Padmasanbhava, great vajra guru, bestow your perfection (on us)'.
Charles Bell

89. Woman from Tromo or the Chumbi Valley with prayer-wheel. The prayer-wheel sends out the prayers written inside it automatically through the action of being turned. In practice, a mantra or prayer is usually intoned simultaneously and the action of turning the wheel also aids concentration on the mantra itself.
Charles Bell

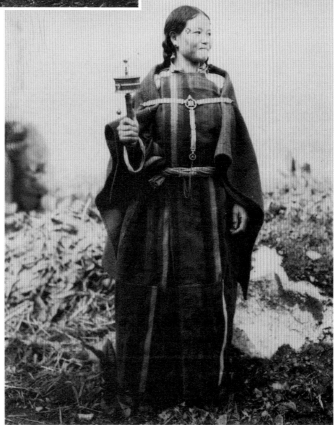

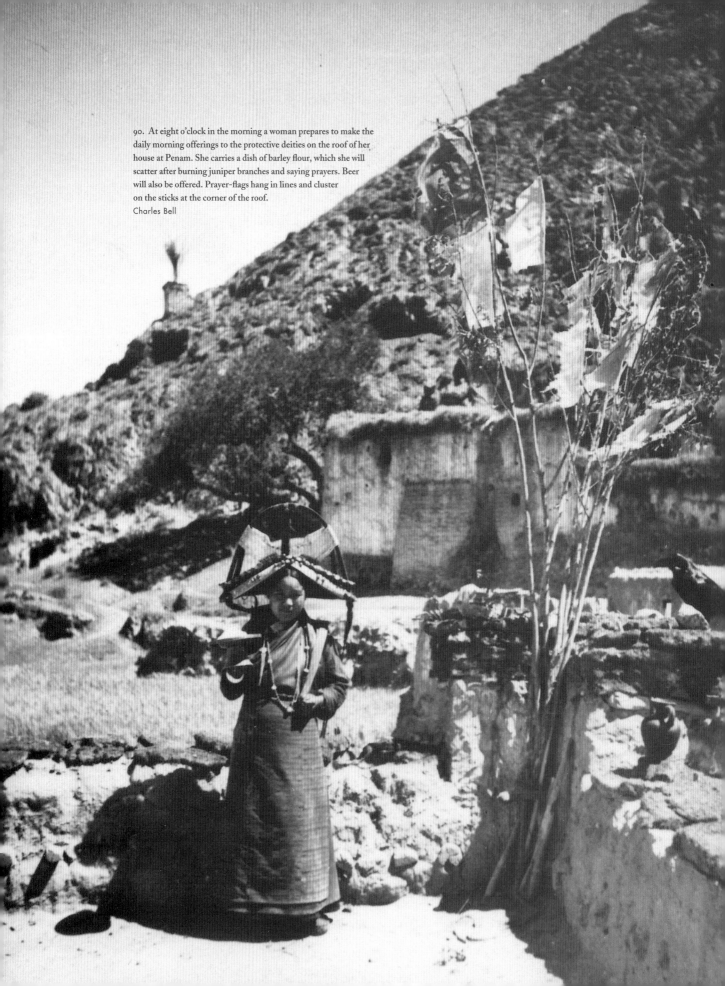

90. At eight o'clock in the morning a woman prepares to make the
daily morning offerings to the protective deities on the roof of her
house at Penam. She carries a dish of barley flour, which she will
scatter after burning juniper branches and saying prayers. Beer
will also be offered. Prayer-flags hang in lines and cluster
on the sticks at the corner of the roof.
Charles Bell

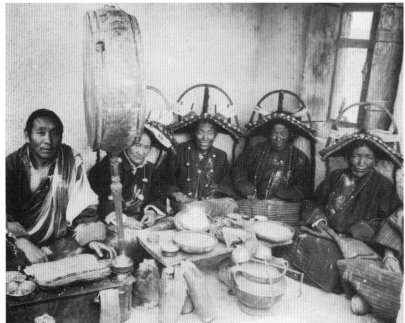

91. A religious service to expel evil and bring abundant crops. It is being held at Dongtse, not far from Gyantse. As he reads from a scripture and invokes the gods, the *nagpa* will periodically sound the large drum or *nga* beside him. Offerings of grain and tea are made to the gods in the ritual dish and stand to the right of his book. Bell commented that it was believed that women's ornaments helped this process of invocation and so they were especially welcome at the ceremony. Food for the human participants is set out on the table in front of the women. The hide bags against the table contain butter, the pot with handles is probably full of barley beer (*chang*).
Charles Bell

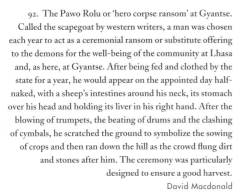

92. The Pawo Rolu or 'hero corpse ransom' at Gyantse. Called the scapegoat by western writers, a man was chosen each year to act as a ceremonial ransom or substitute offering to the demons for the well-being of the community at Lhasa and, as here, at Gyantse. After being fed and clothed by the state for a year, he would appear on the appointed day half-naked, with a sheep's intestines around his neck, its stomach over his head and holding its liver in his right hand. After the blowing of trumpets, the beating of drums and the clashing of cymbals, he scratched the ground to symbolize the sowing of crops and then ran down the hill as the crowd flung dirt and stones after him. The ceremony was particularly designed to ensure a good harvest.
David Macdonald

93. Sky burial. With wood scarce and the ground frozen for long periods, there are practical as well as religious reasons for the disposal of the dead by air or sky burial. At this stage, the flesh has been cut off the bones and is being fed to the vultures. The bones are similarly disposed of after being crushed and mixed with barley flour. Cremation was mostly reserved for high lamas, burial for babies and those dying of infectious diseases. Only the most important religious figures, the Dalai Lamas and the Panchen Lamas, were embalmed and placed in stupas. Though air burial has a brutal aspect, considerable effort is expended in ceremonies to assist the consciousness of the departed into and through the *bardo*, the intermediate state between death and a new rebirth.
Charles Bell

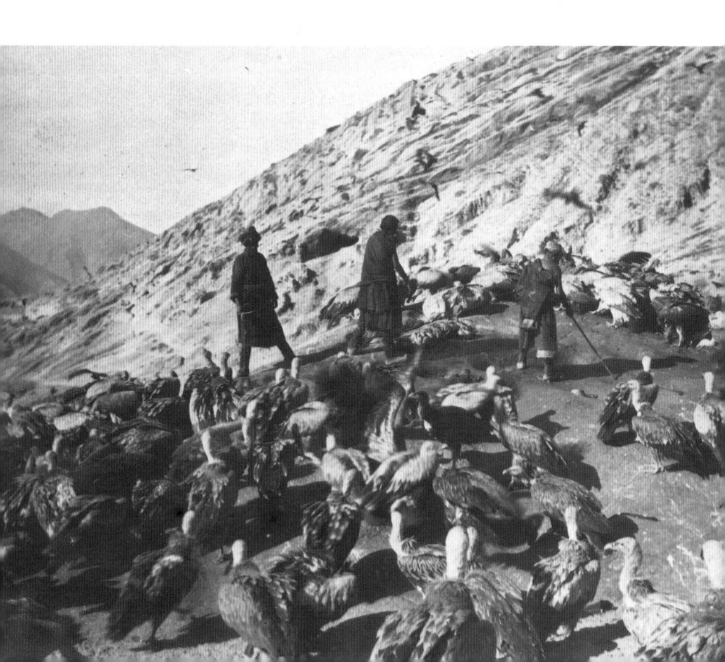

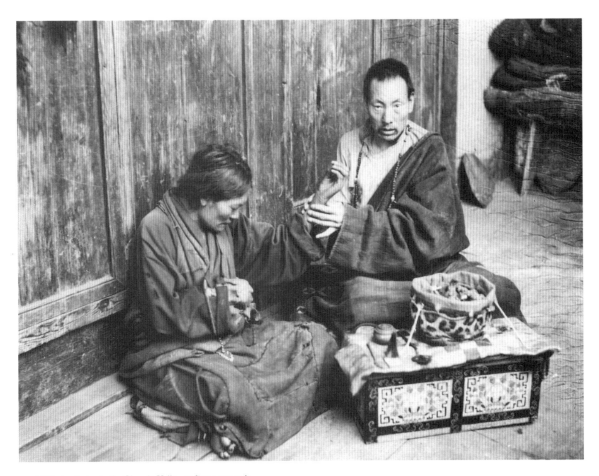

94. A Tibetan doctor in the Chumbi Valley reading a woman's
pulse. A main feature of Tibetan medicine is diagnosis through the
reading of pulses. Many of the 404 diseases described in the four
medical tantras are caused through imbalances in the three main
types of inner energy present in the body (wind, bile and phlegm).
These represent consciousness, metabolism and matter respectively.
Each of the energies has its characteristic beat and each disease its
own 'signature' beat, described both exactly and poetically in the
tantras. Thus the pulse indicating approaching death is 'like a flag
fluttering in the wind'. It was reckoned that mastery of pulse reading
took ten years, though it was taught formally for only one in the
Lhasa medical institutes. The drugs in this doctor's leather bag are
drawn from a wide variety of herbs, animal substances and minerals,
carefully combined to restore humoral balance. The horn on the
cloth is used for blood-letting, which, like acupuncture,
moxibustion and the analysis of urine, formed complementary
medical practises in Tibet. Although medicine was part of religious
education, there were also many secular doctors.
Charles Bell

95. The most visually impressive part of the Lingkor as it cut across
the south-western shoulder of Chakpori (the Iron Hill). Here, the
upper part of the path was flanked by hundreds of Buddhas, some
carved from the rock, others on slates. Amongst them were
different types of offerings, including innumerable figures stamped
in clay and the horns of animals.

Charles Bell

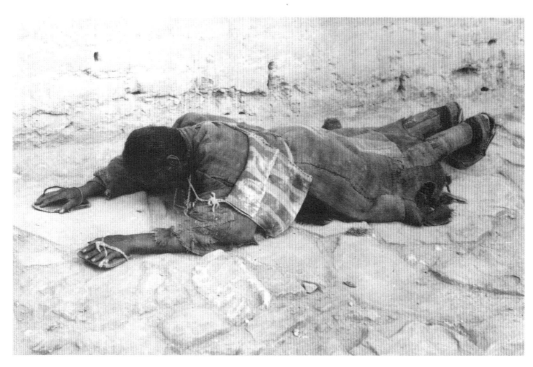

96. A monk performing prostration on the Lingkor at Gyantse. Prostration, an integral part of Tibetan worship, is designed to increase humility and impress religious truth on the body. It is not confined to pilgrimage alone and is carried out before worshipping deities in a temple, when making an offering or before meditational practice. When used in circumambulation, the person lays on the ground stretching their arms out and touching their forehead on the ground. A marker is left at the point their hands have touched, and this is where the next prostration begins. They then stand up, place their hands together in a praying position and touch their forehead with their hands before kneeling and repeating the process.
Charles Bell

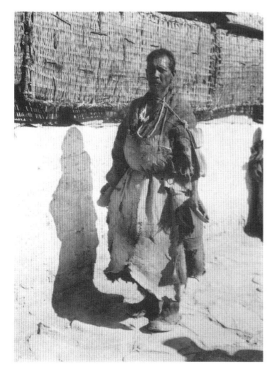

97. To protect themselves from the rocky ground most pilgrims wore a sheepskin apron and heavy wooden blocks on their hands like the ones this monk pilgrim carries. Prostration was not confined to relatively short pilgrim circuits, even long pilgrimages from eastern Tibet to Lhasa or from Lhasa to Mount Kailash, 500 miles away in western Tibet, were undertaken by measuring one's length on the ground.
Charles Bell

98. Pilgrim belonging to the Nyingma order on the Lingkor. Every type of pilgrim and beggar could be found on this five-mile route. Bell said that this man was an imbecile. His trident represents the 'Three Precious Ones': the Buddha, his teachings and the community of believers.
Charles Bell

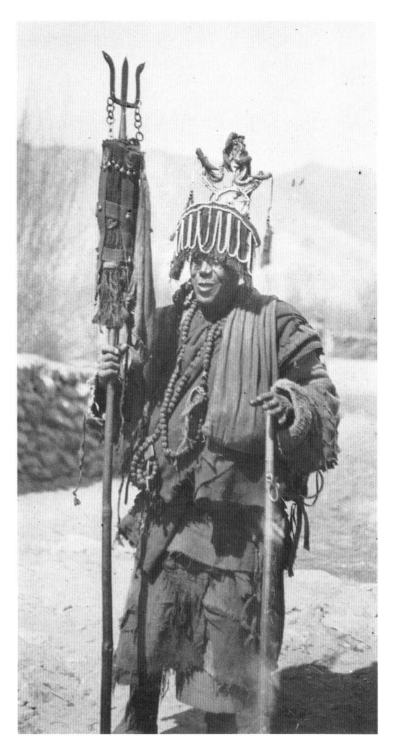

99. A lama taking a family to Tashilunpho monastery and then on to Nepal on pilgrimage. Right to left: mother, seven-year-old son, lama, dog, father and daughter. Tents, blankets, food supplies and cooking utensils are carried and even the boy has a small container strapped to his back. As most families had a son in the monkhood, it is quite possible that the lama is a family member.
Charles Bell

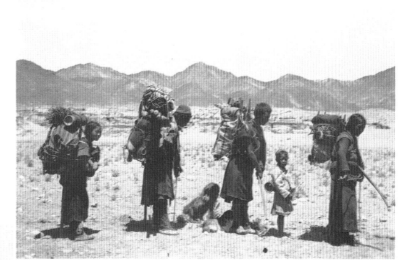

100. The lama pilgrim who leads a family on pilgrimage in the photograph above. Note the religious book strapped to the top of his bundle.
Charles Bell

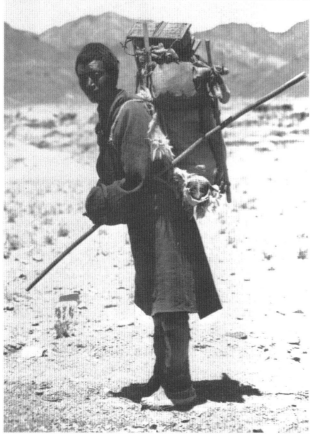

101. This fourteen-year-old reincarnate lama or *tulku* is the head of the Nangto Kyiphu monastery, to which the dark retreat cells below are attached. Theoretically, reincarnates represent the bodhisattva ideal (see pp. 80–2) in action, where, after death, an evolved being choses to be reborn on the earth to guide and inspire his followers. *Tulkus* are recognized as infants by a combination of indications. Before death they may have given predictions about the circumstances of their next birth. They may also be tested for their ability to recognize personal objects they formerly owned or be recognized by those still living who knew them previously. There were over 4,000 *tulkus* in Tibet before 1959.
Charles Bell

102. Nangto Kyiphu hermitage, 'the Happy Caves of the Upper Nyang River', thirteen miles north of Gyantse. In this type of enclosed cell monks undertook retreats in near total darkness and silence for varying lengths of time. It is standard for a monk to undertake a retreat of three years, three months and three days (with a smaller number returning to hermitages for further retreats). At the time this was taken (*c.* 1910–20) there were thirty occupants in the fifty cells. A few had taken the vow to remain in retreat for the rest of their life. Cells measured twelve foot square with low roofs and were completely unheated. A small aperture closed by a trap-door was the only means of communication for each cell. Each day food was brought by an attendant and left on a ledge outside. In his book *Twenty Years in Tibet* Macdonald, who took this picture, voiced the usual western opinion on the sadness of wasted lives that the practice involved. From the Tibetan viewpoint such retreats are a part of a spiritual technology, giving optimum conditions for visualization and meditational states, particularly those that equate the mind with inner light. Interestingly, convicts immured under similar conditions of total darkness in Alcatraz reported that after some time a light would appear to them in which, as they put it, they could 'go on journeys'.
David Macdonald

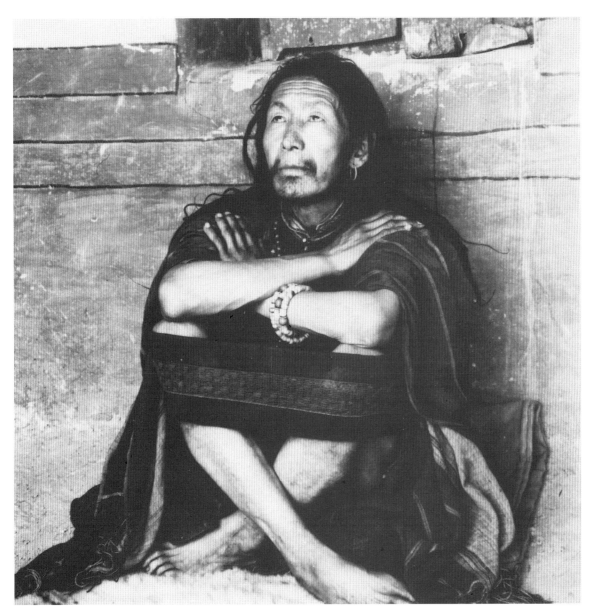

103. A 53-year-old Nyingma yogi in one of the characteristic meditation
postures of the esoteric Zogchen teachings. His posture is maintained by the
meditation band around his legs. Bell's head bearer said that he knew him well,
their houses in Gyantse being close to each other, and that he had already
gained several yogic attainments (*siddhi*). Among these was the ability to
generate inner heat (through a form of yoga called *thum-mo*) and to speed walk
(*gyok lung* or *lung gompa*). He added that people had great faith in his spiritual
abilities. This lama was married, which was permitted in the Nyingma order.
Charles Bell

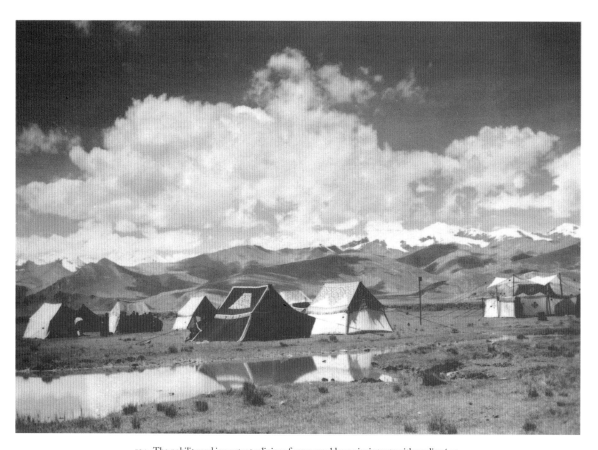

104. The nobility and important religious figures would use picnic tents with appliqué or painted designs such as these for summer picnics. These belong to Dorje Phagmo (see opposite), probably picnicking close to her monastery at Samding in central Tibet.
Charles Bell

105. Dorje Phagmo, the only female incarnate lama in Tibet and the abbess of Samding
monastery near Yamdrok lake. This was the only monastery in Tibet where a female
incarnation presided over a body of monks. She incarnated a tutelary deity, Dorje Phagmo
('the Diamond Sow'), who represents emptiness.

Charles Bell

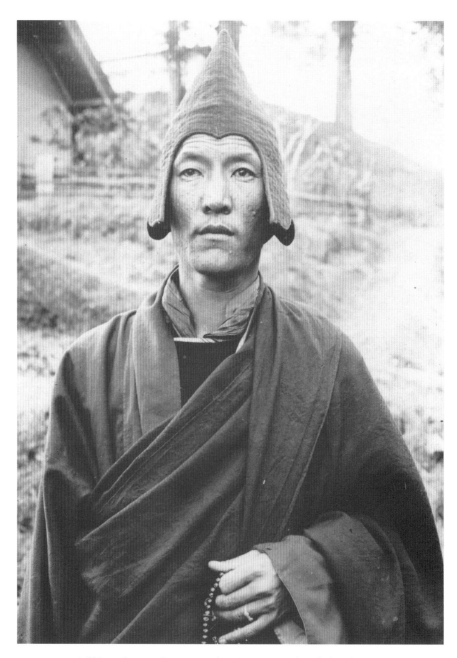

106. Nyingma lama carrying a rosary and wearing a maroon robe and what is known as
a *pundit's* hat. The pundit's hat, named from the Sanskrit word for scholar (*pundita*),
was brought from India at an early date and was worn in Tibet mainly by lamas of the
Nyingma and Kagyu orders.
Charles Bell

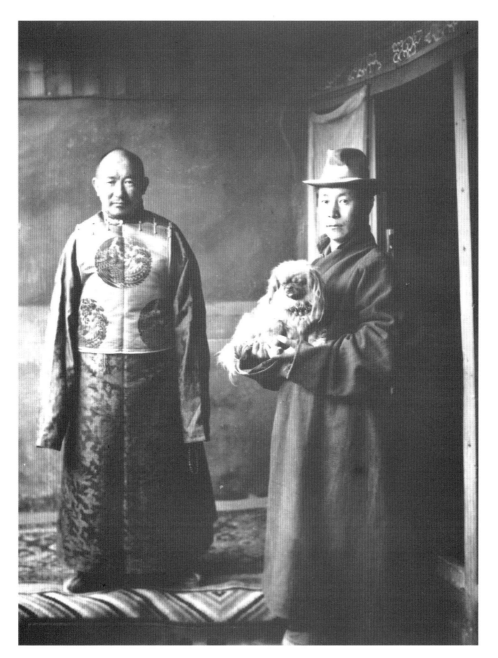

107. The Kenchung (high monastic official), who showed Bell around Tashilhunpo monastery, and his servant carrying his dog. He wears Chinese brocade clothing with long sleeves in the manner of the nobility. Monk officials had their own servants and even ordinary monks could hold private property.

Charles Bell

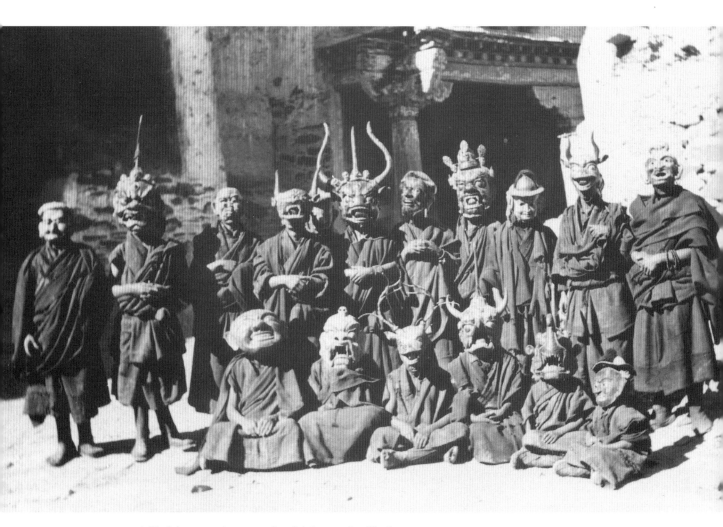

108. Monk dancers pose in a group to show their dance-masks at Nanying
monastery near Gyantse. Monastic dance (*cham*) is a dramatic representation of the
Buddhist deities. It is only performed on festival days in the courtyards of
monasteries or outside temples. Monks dressed in brocade robes and wearing the
type of masks seen here perform a slow circular dance, which recreates the circular
form of the deities' own ritual circle (*mandala*). Here the monks are wearing their
ordinary robes rather than dance costumes and have put the painted masks on just
for the photograph. Characters portrayed include fierce, protective deities such as the
bull-headed Yama, Lord of Death (centre back), a stag (seated) and clowns. *Cham*
confers blessings on the spectators, while for the participants it becomes a meditation
enabling an identification with the deities they portray.
Charles Bell

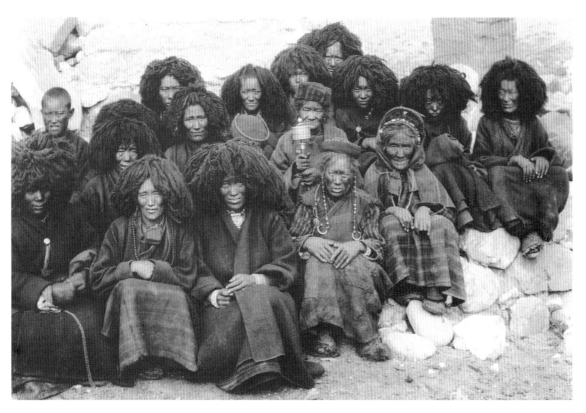

109. Tibetan nuns at Tatsang on the Sikkimese–Tibetan border. White, who took this photograph, blithely commented: 'Our visit was a red letter day to the women as some of them had never seen a white man before. The wigs are made of sheep's wool and like the rest of their clothes, are indescribably dirty.' Nuns had shaved heads and sometimes wore wigs such as these, dyed red or yellow, when outside the nunnery.
John Claude White

110. Monks feed deer at Reting monastery, about 60 miles north of Lhasa. Western visitors often commented on the teeming wildlife and the tameness of some animals. As Buddhist teachings stressed the negative karmic implications of taking life, hunting was the exception rather than the rule in central Tibet. Meat, however, was eaten by many in a harsh climate where animals were much easier to rear than crops, fruit or vegetables. Reting was set in a beautiful juniper wood, which provided shelter for deer and other animals. One of Tibet's most ancient monasteries, Reting was built in 1057 by Drom Tonpa, Atisha's chief disciple (see p. 12).
Charles Bell

111. Monks feeding dogs at Tashilhunpo monastery as an act of charity. Here they are being called. Large packs of semi-wild dogs are still a feature of the monastery environs today, where they continue to be fed by the monks.
Charles Bell

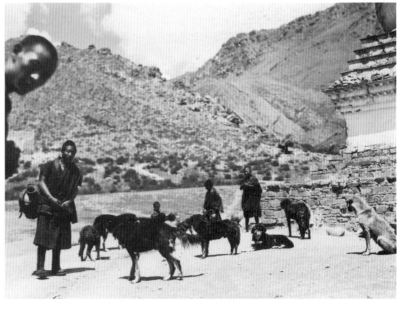

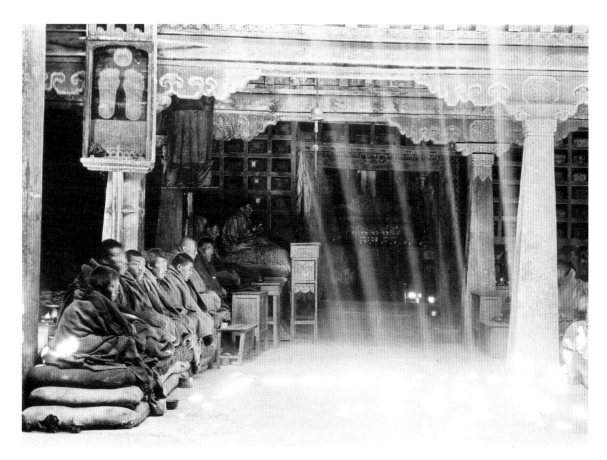

112. Monks during a service at Nanying monastery, seven miles from Gyantse. Two rows
of monks sit facing each other across a central aisle. At their head and slightly raised, the
precentor (*umdze* or *rolpon*), holding a bell in one hand, leads the prayers and invocation
of the deities. Behind him a bookcase with compartments, each containing a volume of
scripture, divides the main hall from the altar area. On a left-hand pillar there hangs a
framed painting featuring two footprints of a revered past religious leader. This would
have been created by tracing around the foot of the person in question, forming an
especially powerful and holy image.

Charles Bell

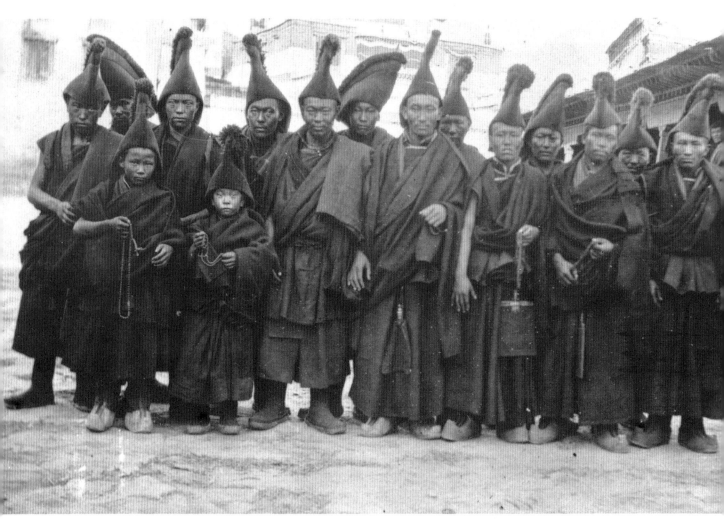

113. A group of Gelukpa monks at the Palkhor Chode
monastery in Gyantse, probably taken before 1924. Crested
yellow woollen hats distinguish monks of the Gelukpa order and
are worn on ceremonial occasions or as here outdoors. Children
like the two in the foreground, perhaps 7 or 8 years old, entered
the monkhood as novices and acted as servants to older monks.
After a few years they could become *geshuls* at which stage they
took 36 vows, while from age 20 it was possible to become a fully
ordained monk (*gelong*) on taking all 253 vows.
David Macdonald

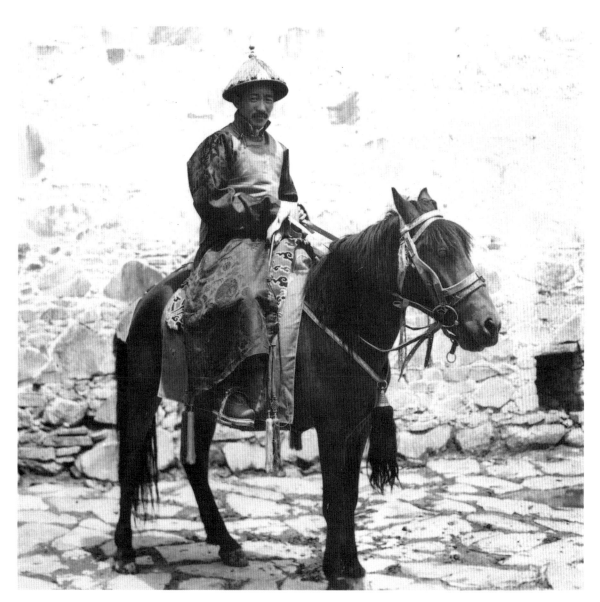

114. Bell described this picture as: 'The priest officer who distributes the barley ration to the monks in Tashilhunpo monastery, mounted on his pony. His official designation is Nor Yon. He is the Chief Magistrate and Paymaster of the monastery and has about eight subordinate magistrates (Shengo) below him.'
Charles Bell

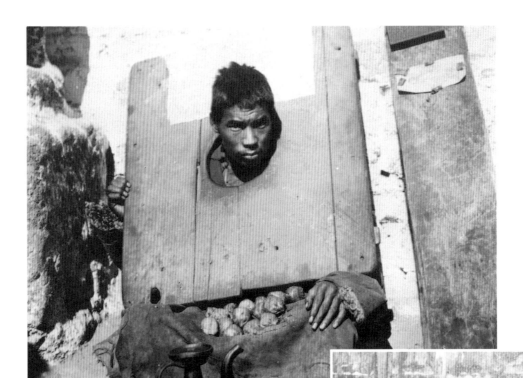

115. Monk wearing a cangue, a wooden board around the neck which restricts movement, as punishment for the forging of currency notes. Details of the offence are pasted on to the board. After confessing to his crime he had been given 100 lashes and placed in this device for a week. It was usual to display offenders in this way in a public place after conviction. Bell commented that he would be likely to get 10 years' imprisonment and, following the new custom, might be made to work in the mint or arsenal.
Charles Bell

116. Two *dob dob*, part of a self-constituted fraternity well known for their inclination for fighting and sportsmanship. They existed as separate groups within the three large Gelukpa monasteries of Drepung, Sera and Ganden, and though frequently skirmishing or engaging in duels were officially tolerated for they performed useful functions as monk policemen at ceremonial events. At those times they held back or cleared the way through the crowds with large staves and whips. Lamas would use them as bodyguards when travelling in dangerous areas, but they were also in demand for their displays of sportsmanship which might be put on at the request of a noble patron. They had their own code of honour which, if infringed, could bring the whole group down on an offending outsider. They often blackened their faces and, as here, carried long staffs.
Charles Bell

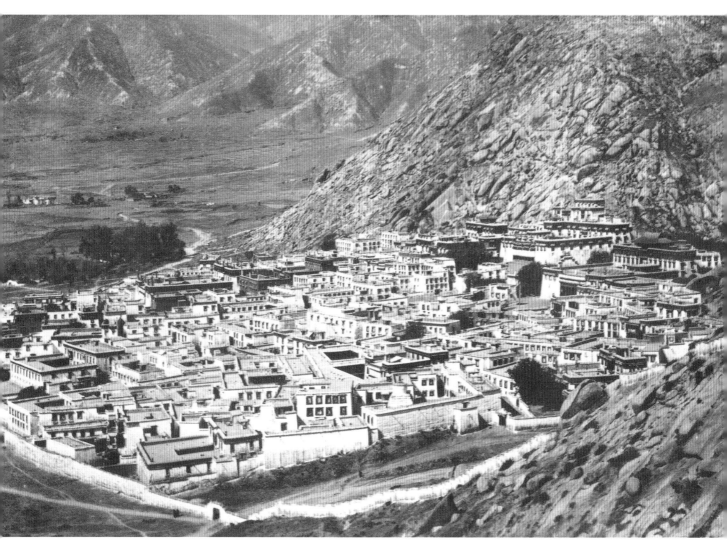

117. Sera, about three miles to the north of Lhasa, was one of the three largest
monasteries in Tibet with a population estimated at around 5,000. While a monastic
town such as this would have a main assembly hall and temple, its basic unit was the
college (*dratsang*). Colleges specialized in specific types of study including logic and
disputation, astrology, medicine and tantric practice. They were almost mini-
monasteries in their own right, each with its own chapels, assembly rooms,
residential quarters and administrative buildings. Each college in turn consisted of
residential houses (*khangtsen*), which tended to have a regional character – in Sera's
case there was a strong link with Mongolia and a number contained mostly
Mongolian monks. It was to the chief teacher of the house that one applied if one
wished to enter a monastery. The range of studies possible in a Tibetan monastery
mirrored that in the ancient Indian monastic universities which were their prototype.
Charles Bell

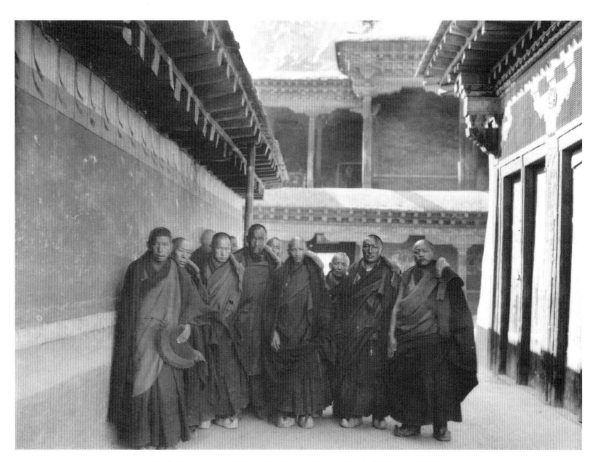

118. A relaxed group of high-ranking lamas, abbots and retired abbots, probably at
Sera monastery. They wear the usual monastic robes of dark red wool, a lower
skirtlike garment held up by a waist sash and pleated at the front, a sleeveless jacket
and, over the top, a large shawl draped across the body over the left shoulder and
under the right arm. Another yellow shawl was also worn for ceremonial occasions,
either over or under the other shawl.

Charles Bell

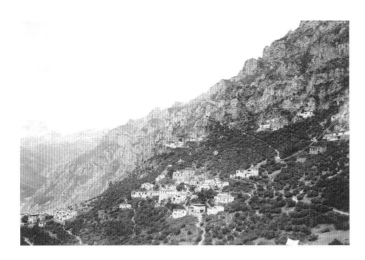

119. The hermitages at Drak Yerpa, about twenty miles north-east of Lhasa. Many of the temples are built against the entrances of caves that riddle the escarpment. By tradition, they have been occupied since the seventh century by many of the greatest Tibetan mystics including Atisha (see p. 12) and his disciples.
Charles Bell

120. Entrance to the main temple at the Palkhor Chode monastery in Gyantse founded in 1425. To the left is the Kumbum, a gigantic *chorten* of the 'many doors' (*tashigomang*) type. Chapels leading off its four levels contain a visual summary of the main classes of tantric teachings in wall paintings and clay statuary of the highest quality. One moves upwards towards the more esoteric teachings on the higher levels. The Kumbum was built and decorated between 1427 and 1440.
Charles Bell

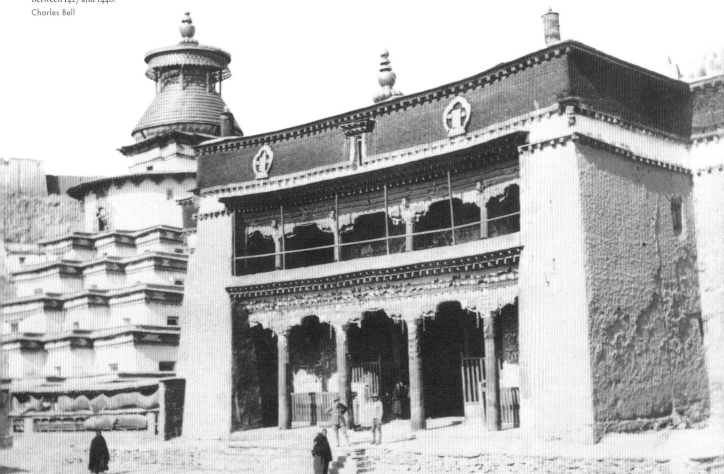

Nobility
and Government

Many of the nobles of Tibet were very wealthy. Their income was derived from the products of their estates, forwarded as tax in kind by their tenants. A large section of the aristocracy took the grant of their lands in the place of salary and were expected to perform duties in the government in return. Some idea of the scale of their resources may be gained from the example of Sir Charles Bell's aristocratic friend Palha, who owned at least 1,400 farms and 13 grazing grounds, each supporting 15 to 20 families of graziers. Noblemen had estate managers who collected and administered income and financial agents engaged in trading, which itself generated more income. In 1945 the Tibetan noblewoman Dorje Yudon Yuthok estimated her family income at around US$21,000, of which half came from the sale of surplus agricultural produce, 10 per cent from sales of their wool in India, 10 per cent from rents on farms and pastures, 5 per cent from house rentals in Lhasa and 25 per cent from trading ventures. Half of this money was used by family members for their personal income but some 40 per cent was given as religious offerings. Wealth also found expression in large family homes that could often be up to four storeys high and which had walled gardens surrounding them. Often these houses and estates were far from Lhasa, requiring the maintenance of other town houses in the capital, the centre of social and political life. Nobles exercised judicial powers over their tenants; they could, for example, flog or imprison them for misconduct without having to refer to any external agency. Tenants also needed to obtain permission from their lord to travel. Monasteries also owned extensive estates with tied peasant farmers or graziers, from whom taxes had to be collected and over whom the monastic authorities exercised justice. In practice, however, local custom, upheld by the village headman, determined and limited the burden placed on tenant farmers or herdsmen.

Tibet was governed by a civil service consisting of 350 officials, of whom half were monks (*tse-trung*) and half laymen drawn from the nobility (*trung-khor*). The foundation of the system was laid at the time of the Fifth Dalai Lama in the mid-seventeenth century and was modified to its final form in the following century. The Dalai Lama, the head of both church and state, had under him a supreme Cabinet of four ministers, three lay and one ecclesiastical (the Kashag, see figure 15). There also existed an advisory body, the Tsongdu, or National Assembly, which met to discuss issues of national importance.

One section of the nobility owed their position to descent from the ancient kings, while others were ennobled through having had a Dalai Lama discovered in their families in the past. But by far the largest group were those who received their titles and lands in return for government service. Unlike the older nobility whose titles and lands were held by hereditary right, the larger group of officials rose by merit and were transferred from post to post. A system based on the Chinese model allowed for eight grades of noble officialdom, each with specific ornaments and dress. Thus, the Prime Minister, being of the first rank, wore a hat with a pearl on the top while the four Cabinet ministers of the Kashag, being of the second rank, had hats decorated with rubies. The nobility's dress was also regulated by season; nobles were only allowed to wear fur hats and cloaks, for example, in the officially designated winter months from December to April. At the end of winter an official ceremony was held in the Potala Palace to mark the transition to summer dress.

Most positions were filled by both lay and ecclesiastical officials. This system was designed to check corruption, though in reality bribery was tacitly acknowledged as a source of income. The ruling nobility usually sent their sons into either the lay civil service or the monkhood. In either case they could rise to positions of considerable power, which was therefore kept concentrated within a few families.

121. Three fettered prisoners convicted of theft. After punishment, which was usually flogging, criminals were often freed to fend for themselves, though fetters or sometimes the cangue (see figure 115) remained on for a set period. Perhaps the man on the right is smiling because he has been given an armful of that favourite Tibetan dish, the radish.
Charles Bell

122. One of the Dalai Lama's secretaries, called Lotru (wisdom) or Tsetrung Kusho ('Secretary at the Peak', i.e. the Potala), mounted and with a servant in attendance. His summer hat of lacquered papier mâché shows that he was an incarnate lama or *tulku*. The bright square of brocade hanging from his waist is the covering to the water bottle (*chablug*), from which monks were required to rinse their mouths in the mornings.
Charles Bell

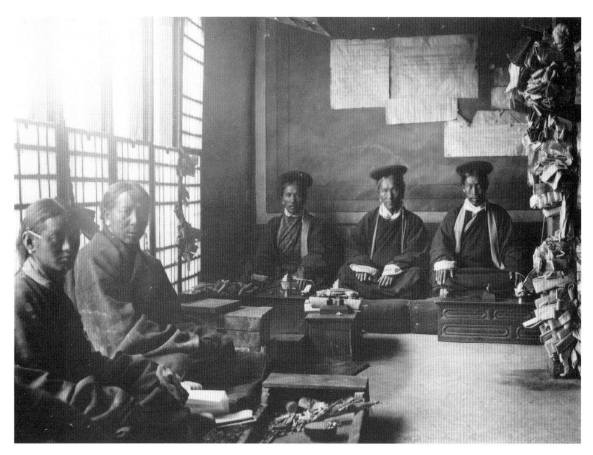

123. A courtroom at Sho, below the Potala. Three magistrates (Sho Depa) are seated against the far wall. They wear red gowns and the round yellow officials' hat or *bokto*. Their two clerks are to the left. Court records are fastened to the walls and pillars to the right. Litigation was expensive and bribery not uncommon. The set fees, graded according to the type of case and status of the litigants, were paid before the case was heard and when fines were imposed a proportion was paid by right to the magistrate and his officials.

Charles Bell

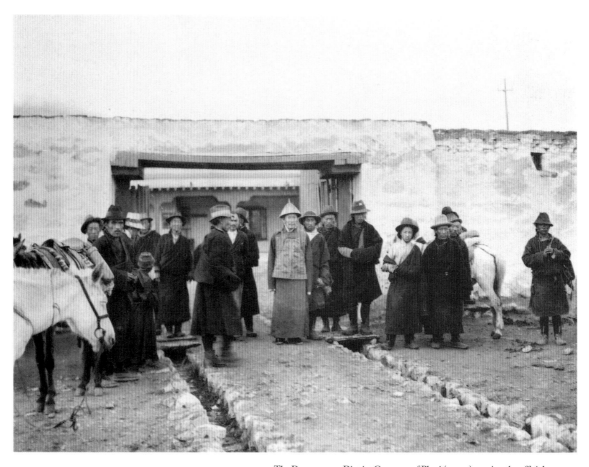

124. The Dzongpon or District Governor of Phari (centre) wearing the official summer hat of the post. Each of the 53 districts of Tibet had two Dzongpons (literally 'Fort Commanders'), one a lay noble and one a monk. They supervised the collection of taxes and acted as judges, trying all civil and criminal cases below their own rank. Like other nobles, the family estate of a Dzongpon would provide a basic salary, but other sources such as monies from fines and bribes would make up the rest.

Charles Bell

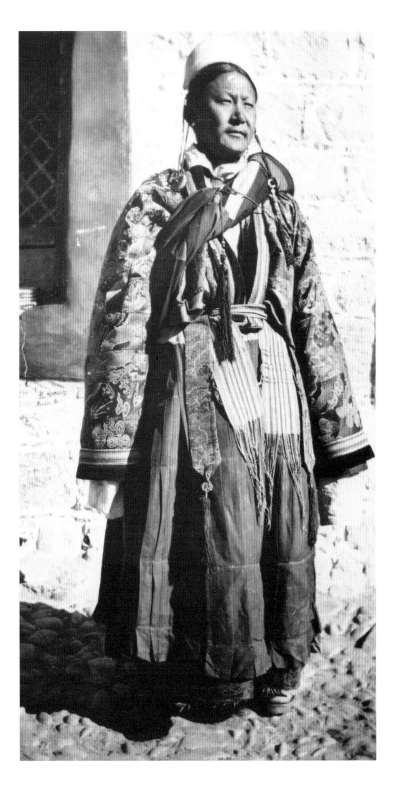

125. Neto Dzongpon outside Bell's kitchen at Lhasa in the *gyaluche* costume worn by all lay officials on the second day of the New Year (Gyalpo Losar). This was believed to be the dress of the ancient royal princes and consisted of a white papier mâché cap, in imitation of an Indian turban, a short silk-brocade jacket and a black pleated skirtlike garment. A rainbow-coloured scarf is also worn over the left shoulder. Neto Dzongpon had the rank of Depon, a military rank corresponding roughly to a general in the west. Neto and Tsetrung Kusho, the Dalai Lama's secretary (see figure 122), were attached to Bell's party on his visit to Lhasa in 1920–1.
Charles Bell

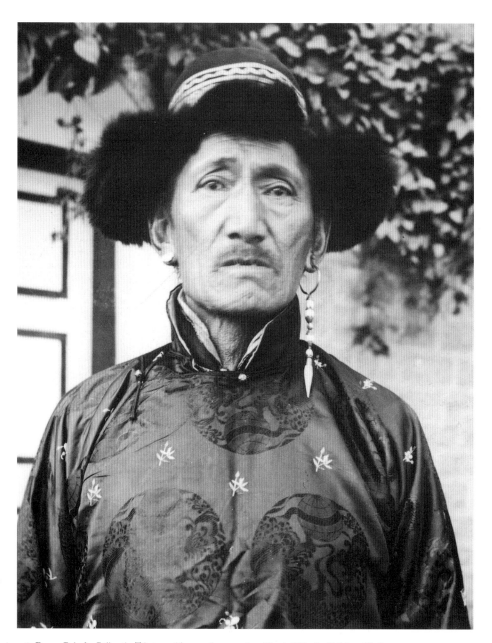

126. Dewan Bahadur Palha, the Tibetan nobleman who was a close friend of Charles Bell from his time as Political Officer. He was awarded the title Dewan Bahadur by the British Indian government for his good service as Confidential Secretary to the Political Officer. Palha later travelled to England to help Bell check the proofs of his books. The Palha family lived at Dongtse, about ten miles from Gyantse in southern Tibet, and had only just regained official favour after the disgrace that had befallen them for having taken in the Bengali spy-explorer Sarat Chandra Das when on his secret journey to Lhasa in 1882.
Charles Bell

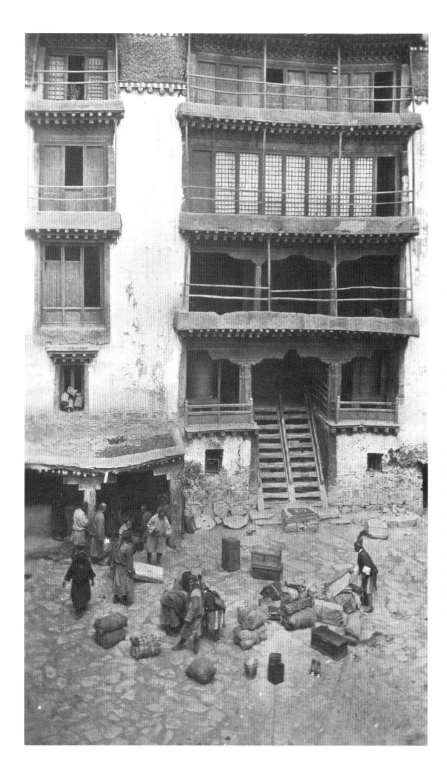

127. The inner courtyard of Penjor Lhunpo, the mansion of the Palha family at Dongtse. This was the highest part of the quadrangular house rising to four floors. The top floor, lived in during the summer, contained sitting-rooms, bedrooms, a kitchen and a schoolroom for the family and retainer's children. On the floor below lay a room for the two stewards who managed the estate, several chapels, including one large one containing all 108 volumes of the Kangyur or scriptures, a large reception room and storerooms. On the second floor were rooms for servants and storage, including two rooms for wool and grain running the entire length of the house. The first floor was taken up by more storage rooms for dried yak, beef and mutton, barley flour, peas, grain and oil. Around the courtyard on the ground floor were the stables and fodder stores. Verandah spaces were used for viewing entertainments in the courtyards and for spinning and weaving woollen cloth. At the top of the typical steep wooden ladder by which one entered were two large prayer-wheels. These were continually turned by two elderly female servants so generating prayers for the household and all sentient beings.
Charles Bell

128. Rai Bahadur Dzasa Norbu Dhondup OBE, CBE (1884–1944) wearing a green Chinese brocade robe and long official's earring in his left ear. Born a Sikkimese Tibetan, he was educated in Darjeeling and picked by Frederick O'Connor to accompany the 1903–4 expedition to Lhasa as interpreter. There followed a succession of posts in the British Indian government including Trade Clerk at Gyantse and Clerk for the Political Officer in Sikkim. He accompanied Bell's mission to Lhasa in 1920 and the two later missions of Frederick Williamson in 1935 and Sir Basil Gould in 1936. He was highly trusted by the British as a man of integrity and intelligence.
Charles Bell

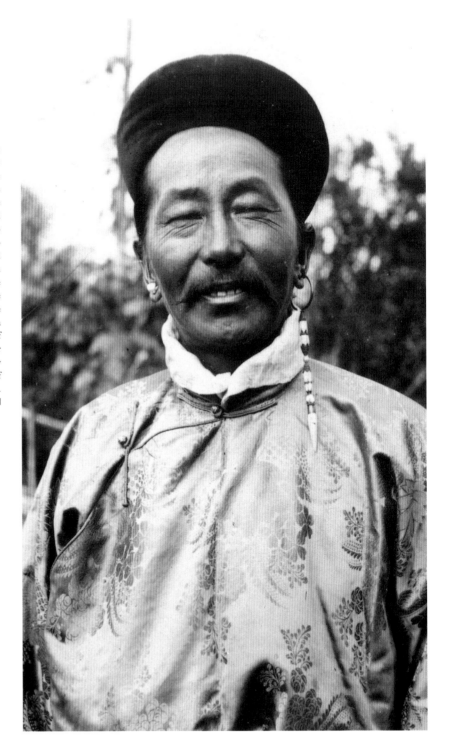

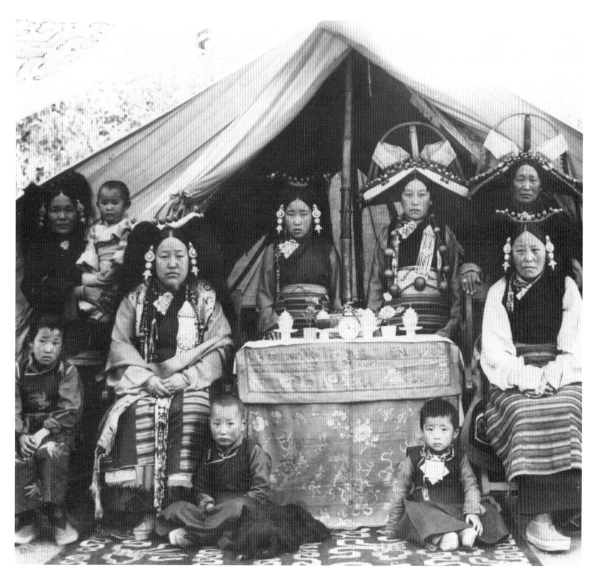

129. Palha's wife, seated left, with her female friend from Dode near Sangang. The children of the two families stand behind. The wives of officials wore their finest jewellery on all important or ceremonial occasions and while travelling. Simpler versions were used for everyday wear. When a girl was betrothed, jewellery and a dress formed part of the dowry. The bridegroom's family sent a complete set of ornaments, including a head-dress, on the day before the wedding.
Charles Bell

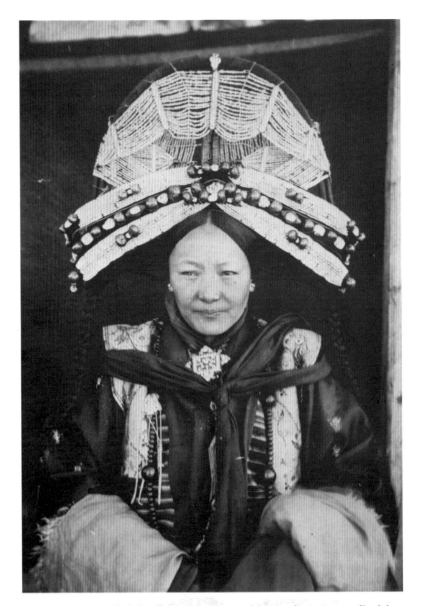

130. Lady from Tsang wearing the most elaborate and expensive type of head-dress of that region, the hoop almost completely covered with ropes of seed-pearls. The quality and profusion of corals (the darker stones) set between turquoises shows her high rank. Her hair, braided into plaits, hangs from the front corners of the frame. Married status was shown by a turquoise set in the middle of the horizontal frame at the back of the head-dress.

W. P. Rosemeyer

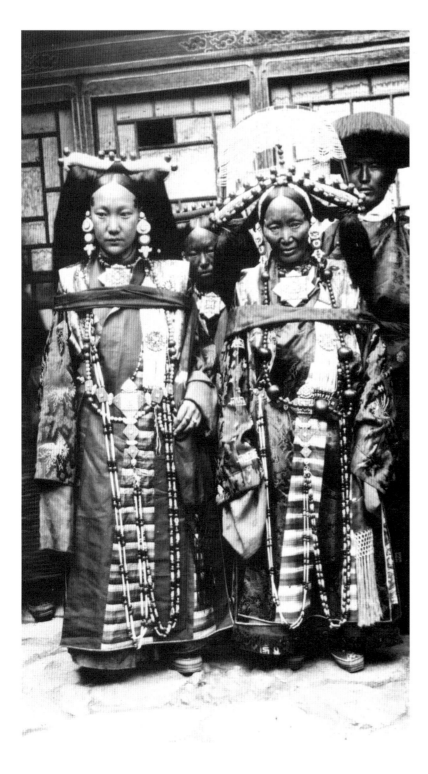

131. Two noblemen's wives in their finest jewellery and head-dresses. The lady on the left wears the Lhasa style of *patruk* or head-dress, the one on the right that of southern Tibet or Tsang. For both men and women jewellery indicated not only wealth but official status. Women wore the jewellery appropriate to their husband's rank. For example, the lady from Lhasa has her triangular, wooden, felt-covered *patruk* encased in pearls with a few splendid corals. A lower-ranking woman would wear only corals. False hair was hung from the front corners of the frame and heavy gold earrings set with turquoise were attached to it at the back with hooks. Both women wear square-shaped gold charm boxes (*gaus*) set with diamonds, corals and turquoises strung on necklaces of beads. The Tsang lady's hoop-shaped head-dress, swathed in seed-pearls, shows that she is of a similar high rank to her companion. The large stones are turquoises and corals.

Charles Bell

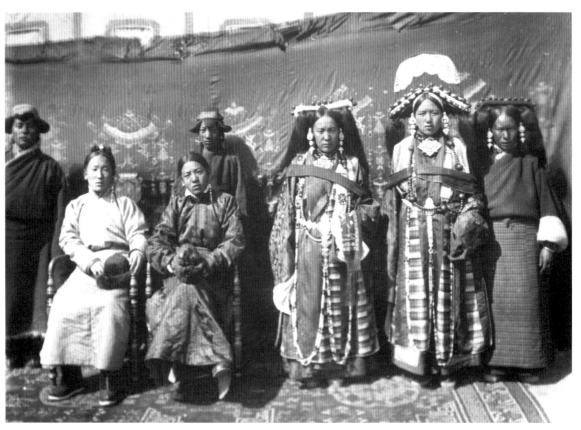

132. The Rakashars, one of the great Lhasa families. Left to right: Rakashar Depon, a commanding officer in the army, and his brother (both seated, two servants stand behind), Rakashar's wife, a lady from Tsang and a servant. Both young noblemen wear the long thin lay official's earring of turquoise and gold in the left ear, but only Rakashar, as an official of the fourth rank, is entitled to wear a small gold and turquoise amulet box in his gathered-up hair. Both jewellery and clothing reflected rank. For example, the yellow or gold silk brocade worn by Rakashar was only permitted to officials of the first to the top of the fourth rank, as yellow was both an imperial Chinese colour and the religious colour of the Geluk order. Lower fourth-grade and fifth-grade officials wore darker-coloured silk of the type his brother wears here.

Charles Bell

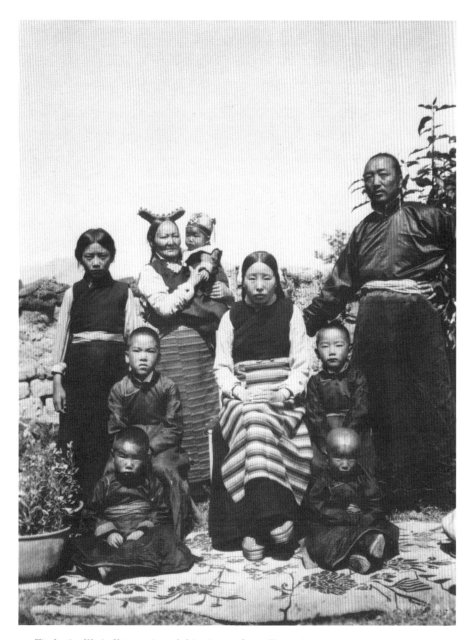

133. The family of Kusho Kyipu on the roof of their house in Lhasa. Kyipu, who was sent to school in England in 1913 (see figure 5) had married by the time this picture was taken in 1933. He is standing on the right, his wife is seated and surrounded by their five children, the youngest being held by a maid wearing a simple Lhasa head-dress. The girl on the left is a relative. Kyipu's wife and the maid wear the striped multi-coloured woollen apron of Lhasa. The fashion in these head-dresses changed between the 1920s and the late 1930s from the flatter version (see opposite and figure 130) to this horned shape.
Charles Bell

Life in Lhasa and Other Towns

Most of Tibet's towns were small by western standards. Lhasa, for example, had only about 20,000 inhabitants in the early 1920s. Shigatse, in southern Tibet, was the second largest with 12,000, followed by Gyantse with 5,000. However, these populations fluctuated widely as numbers increased at festival and market times. Lhasa's is estimated to have quadrupled at the New Year, while at any one time perhaps half of Shigatse's population were traders and pilgrims. Most of the social life of Lhasa and other towns, as in medieval Europe, revolved around festivals. Almost all of these were religious or in some way connected to religion. By far the most important was the Great Prayer Festival (Monlam Chenmo), a spectacular series of religious ceremonies and games lasting three weeks. They were held in February or March and formed the heart of the New Year festivities. During the Great Prayer Festival, on the fifteenth day of the first Tibetan month, the Dalai Lama would hold a religious ceremony and preach a public sermon near the Jokhang. Lhasa was the religious, political and commercial capital, with the Dalai Lama residing in the Potala, a mile away from the city, throughout the winter months. During the summer he moved to the Norbulingka, just to the west of the city. Below the Potala at Sho were the courtrooms, prisons, stables, granaries, printing works and craft workshops (see figure 158). A police force had been introduced as part of the modernization programme in the 1920s, but it was despised by the people and was constantly at loggerheads with the army. Prior to the 1920s those who disposed of corpses (the *ragyapas*, see figure 82) had the job of pursuing criminals and carrying out executions and blindings. Punishments were harsh: amputation was common for repeated robbery while murderers or those who had stolen from high officials were blinded. Suspects were brought before judges but there was no trial by jury. Government provision for the secular needs of society was quite small. The only state-run schools were for state officials themselves: the Tsikhang trained lay officials in accounting and the correct forms of address in official correspondence, and the Tse Laptra trained the monastic officials. Private schools also existed for laymen in many towns, Lhasa itself had around 30 in the 1920s. The government ran two medical training centres. To the south of the Potala Palace lay the Chakpori medical college founded in the seventeenth century (see figure 134). On the west side of Lhasa was a second medical institute, the Mentsikhang, founded by the Thirteenth Dalai Lama in 1916. As at

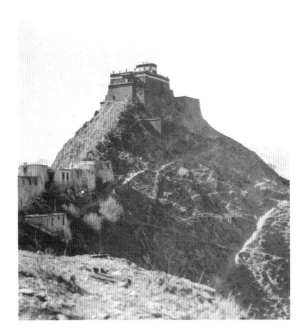

134. **The medical college on Chakpori, the Iron Hill, in south-west Lhasa. It was founded in 1696 by Samye Gyatso, the Fifth Dalai Lama's regent, as a training institute for monk doctors.**
Charles Bell

the Chakpori college, students from monasteries all over Tibet were trained here for up to eleven years. The government also maintained a military depot, a mint and an arsenal on the Trapchi plain to the north of the city.

In the centre of the city the old houses and narrow lanes converged on the seventh-century Jokhang temple, the earliest and most holy temple in Tibet (see p. 9). Encircling it was the Barkhor, the commercial centre of Lhasa, a street of shops and stalls. There were many Nepalese shops here, some selling precious stones, and Newari craftsmen worked nearby. Other shops were owned by Muslims, who sold imported fabrics and cosmetics, and Bhutanese and Chumbi Valley traders. As the

terminus of the caravans from China, Mongolia and India, Lhasa had the widest range of products on sale in Tibet. Brick tea, silks and brocades from China, Indian hardware, sugar, tobacco and manufactured items, could be found amongst locally made clothes, boots and leather goods. High-quality eastern Tibetan saddles decorated with fine metalwork and stirrups were also on sale. Further out, in different sectors of the Lingkor, were the houses of the lower or despised professions, the corpse-cutters (see figure 82) and other beggars, the leather workers and butchers.

Shigatse had the second largest market (see figure 154), selling imported Indian goods as well as locally made rugs, metalwork and fine silverware for which the town was known. Gyantse was a centre of the wool trade and carpet industry and had an important market (see figure 157). Wool was brought there from the estates of nobles for weighing and exporting. Both Shigatse and Gyantse were home to a number of small commercial workshops weaving carpets for sale in local markets or for trade. Shigatse was most famous for the nearby Tashilunpho monastery, the seat of the Panchen Lama and a centre of pilgrimage for this reason. With 4,000 monks it rivalled the large monasteries of Lhasa. A village of craftsmen, mainly painters and metalworkers, lived outside the monastery and worked for it.

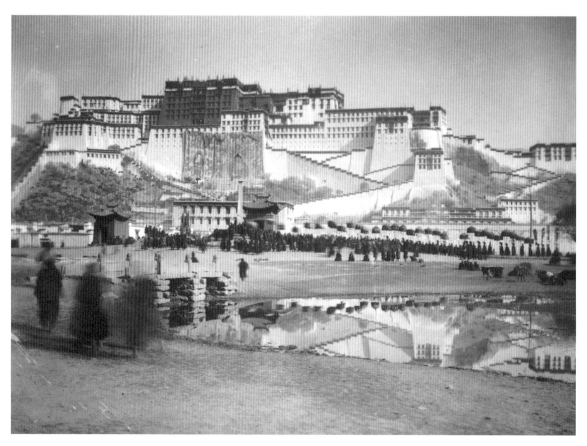

135. The Golden Procession (Sertreng) held in the second month (March/April), which
commemorated a vision of the Fifth Dalai Lama. In the Sertreng hundreds of monks, some
carrying precious religious objects, others large umbrellas or banners of victory (symbolizing the
attainment of Enlightenment), encircled the Potala Palace on the Lingkor. Monks playing
musical instruments and the State Oracle also formed part of the procession. Before passing
through the west gate (to the left) and beginning the walk on the Lingkor, they paused for
dances and the hoisting of the large silk banner on the lower face of the Potala.

Charles Bell

136. A section of the Lingkor or outer pilgrim route that encompassed Lhasa in a five-mile circuit. If pilgrims had come from far it was common to make the entire circuit by prostration, measuring their length on the ground. This normally took three days, but the particularly devout made each prostration keeping the Potala on their right. This meant they measured the distance by body widths and took five days. Circumambulation must always be carried out in a clockwise direction around a sacred structure, which is thereby kept on one's right. Here the Lingkor, skirting the Iron Hill, descended so steeply that prostration became difficult.
John Claude White

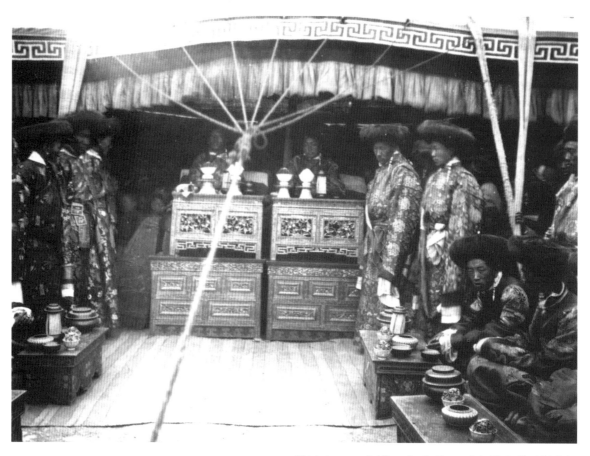

137. This is the event called 'Preparing the Camp at Lubu' (Lubu Gardrik), Lubu being the place where the cavalry will assemble before a review takes place. The two 'Highest Worshippers' (Yasos) presiding over the New Year ceremonies were photographed by Bell on 1 March 1921. The Yasos sit in shadow at the end of the enclosure with two tables stacked in front of each, following the custom of the more important officials sitting higher than their subordinates. Other nobles and their servants are at the side. All the participants are dressed in their finest silks or brocades with fur-brimmed hats in the Mongolian style. Much of the ceremonial and costume, including a parade of cavalry in antique armour, were instituted by the Fifth Dalai Lama to recall the military might of the Mongols who ensured his dominance of Tibet (see p. 15). The New Year ceremonies and games were seen collectively as an invitation to the future Buddha, Maitreya (Champa), to come to earth and establish his reign of peace. The two Yasos would make a formal statement from their thrones about the events to follow and their significance.

Charles Bell

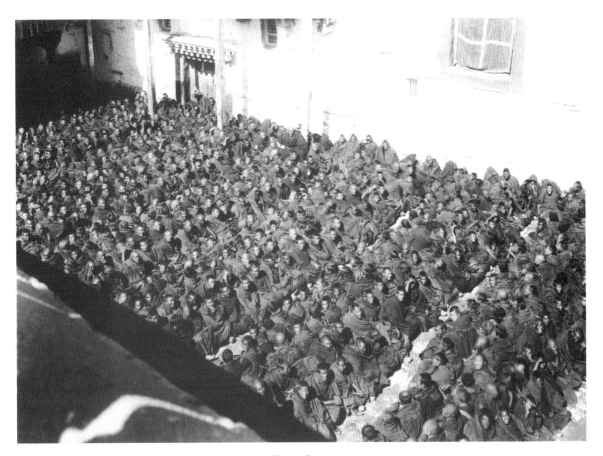

138. Monks crowding an area outside the Jokhang temple during the Monlam Chenmo
(Great Prayer Festival) held in the first month (February/March). Up to 20,000 monks
from Sera, Drepung, Ganden and elsewhere poured into the city for the ceremonies
and celebrations that lasted three weeks. So great was the number that once all available
space in the Jokhang was filled, monks were forced to sit here in the Barkhor, the
pilgrim road encircling the Jokhang.
Charles Bell

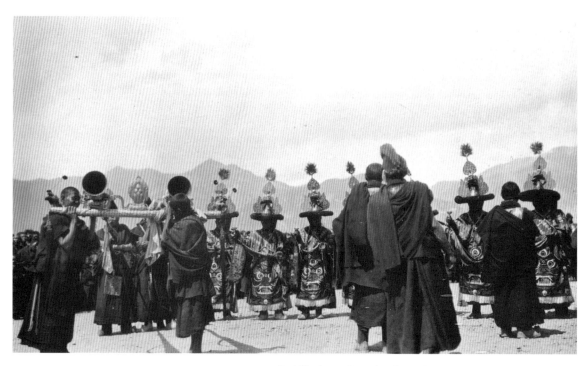

139. Black Hat dancers (*Shanak*) perform at the start of the ransom ceremony (Lugong Gyalpo) to ensure the well-being of the Dalai Lama and Lhasa as a whole. The monks at the left carry ten-foot-long copper or brass trumpets on shoulder rests decorated with the auspicious 'wish-granting jewel'. The Black Hat dance is said to commemorate the killing of Langdarma, the anti-Buddhist king, in the ninth century (see p. 11). The dancers circle slowly in their brocade garments. They wear aprons bearing the angry face of a protector of religion and hold ritual vessels. The dances take place on the twenty-ninth day of the second Tibetan month (March/April).
Charles Bell

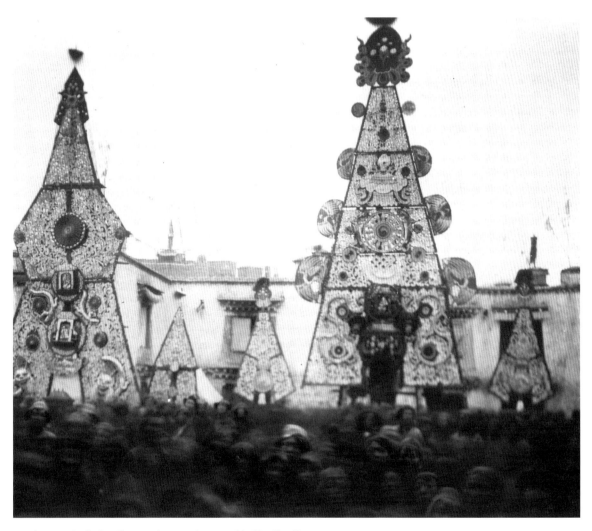

140. A spectacular display of butter sculpture made as part of the New Year Great
Prayer Festival. It was known as Choenga Choepa or the 'Offerings of the
Fifteenth', falling on the night of the fifteenth day of the first month
(February/March). The delicate sculptures were created over triangular leather
frames and attached to scaffolding erected around the Barkhor, the road encircling
the Jokhang temple. Gods, goddesses, lamas, mythical beasts and Buddhist
symbols formed the subjects. Nobles and monks from the large monasteries
competed to produce the best display, a contest judged by the Dalai Lama himself
at the start of the evening. During the night the sculptures were lit by butter-
lamps, torches and Japanese lanterns while the crowds continued singing and
merry-making until dawn. At daybreak the sculptures were dismantled.
Charles Bell

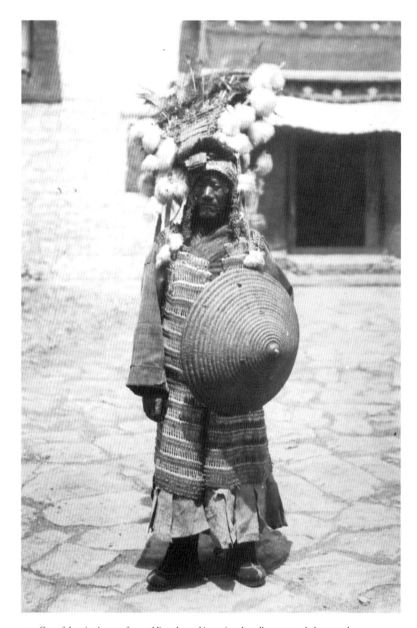

141. One of the *zimchongpa*, foot-soldiers dressed in ancient lamellar armour, helmets and shields. Numbering about 200, they were based at Sho below the Potala Palace and were supposed to be descendants of Gusri Khan's Mongol infantry (see p. 15). At the Great Prayer Festival they put on displays of mock martial prowess in front of the Jokhang temple, firing off matchlocks and brandishing swords and wickerwork shields.
Charles Bell

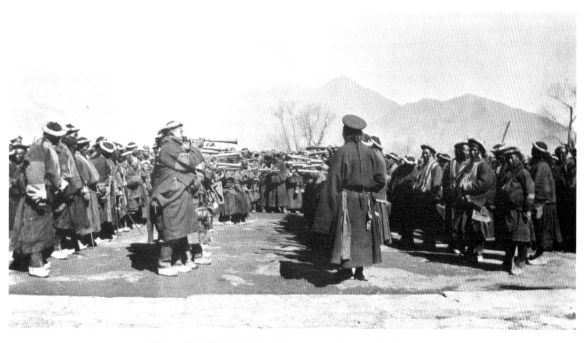

142. Divine soldiers (*Lha Makmi*) who blew trumpets at the arrow-shooting contest, part
of the Gutor ceremony that took place in the twelfth Tibetan month (January/February).
Charles Bell

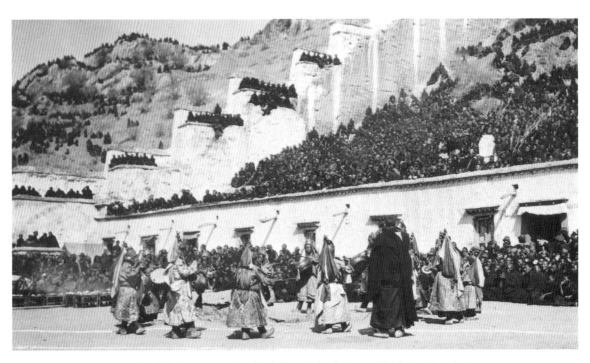

143. One of the dances in front of the Potala Palace during the Sertreng (the Golden Procession).
Onlookers have taken every available space on the rocky slopes of the Potala hill.
Charles Bell

144. Monks of the Sakya order performing a dance in front of the Potala during the
Sertreng (the Golden Procession). The exacting and strenuous steps involved turning in
circles and leaping into the air. The large drums they carry on their backs were beaten with
two curved sticks, one held in each hand. They are dressed in blue brocade waistcoats and
have yellow aprons over their skirts.

Charles Bell

145. A family of performing beggars show off their skills for Bell. The father wears a hunter's mask from the Ache Lhamo dances, and plays cymbals. One of his small sons plays a fiddle while his daughters beat hand-held drums.

Charles Bell

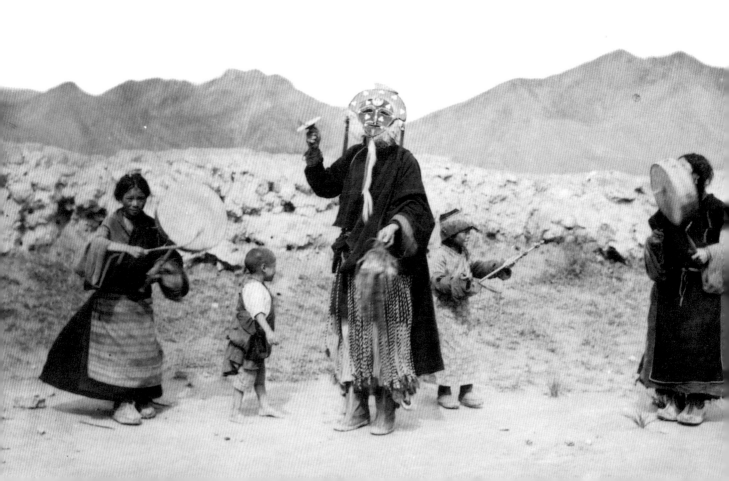

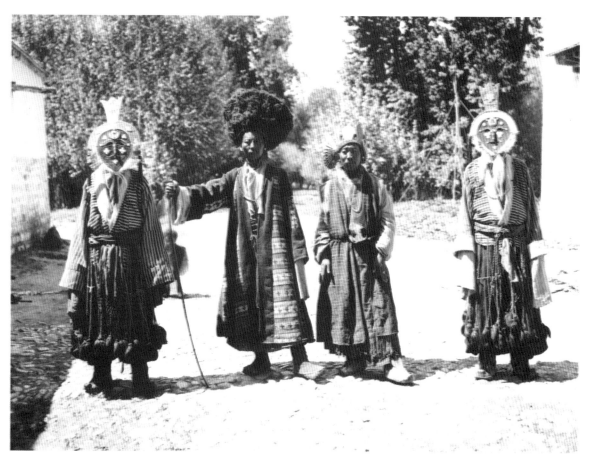

146. Four performers in the Kyomolung theatrical troupe. Musical dramas called Ache Lhamo, telling the stories of the Buddha's former lives, the early kings and other heroes, were performed as part of the harvest festival throughout Tibet. In Lhasa, performances were part of the Shotrun (curd feast) festival in the late summer. Characters were recognizable from their masks and sang their parts in a high-pitched voice. Despite the emphasis on moral and religious themes, there were usually comic interludes satirizing all levels of society. The performers were mostly men (playing women's parts when necessary), and were villagers or traders who gathered at this time of year to tour together. The triangular masks worn by a number of characters are called hunter's masks and are made of felt and fringed with wool. The character of the hunter was derived from the ancient story of a bodhisattva who incarnated in human form and as a fisherman carried off a fairy or 'Sister Goddess' (Ache Lhamo), after which the dramas are named. The goddess here is represented by the man wearing the fan-like ear decorations. The Ache Lhamo dances are said to have been introduced by the saint and iron-bridge builder Thangtong Gyalpo as a means of raising money for the bridges (see figure 37).
Charles Bell

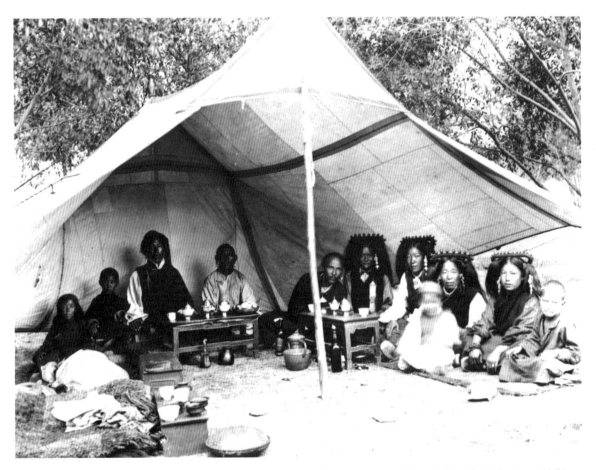

147. A picnic party in one of the parks (*lingkas*) near the river outside Lhasa. Throughout the summer picnics were a major feature of Tibetan social life. Most people in Lhasa would have two or three a month and monks had their own separate gatherings. Often a number of families would combine to share expenses; cooks would be hired and dancers brought in to put on displays. A picnic could last up to five days, the merry-making starting at nine or ten each morning and going on until five or six in the evening. Tea was served throughout in the raised covered cups seen on the low tables, followed by plenty of barley beer (*chang*) after midday. Special food would also be served: at the start perhaps fried rice, bread rolls, dried fruit and cheese, and at about two o'clock in the afternoon a Chinese meal with several courses.

Charles Bell

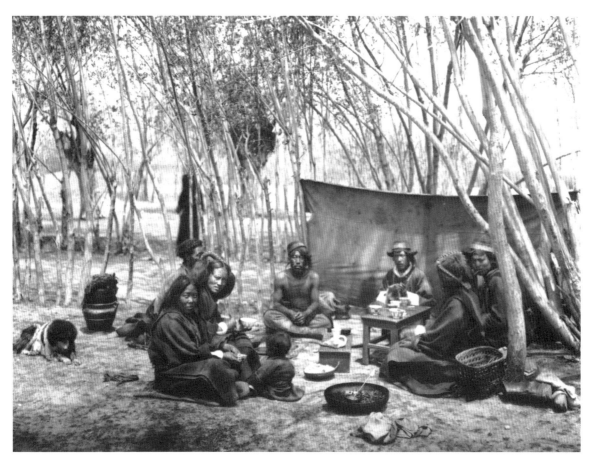

148. The picnic of a lower income group than that opposite among a willow grove outside
Lhasa. Tea is being kept warm on a brazier to the left next to the mastiff; a wind-break is
erected instead of a tent. After the midday meal there would be singing, helped along by
the barley beer (*chang*), and games such as *ba* (see figure 7) would be played. The cups here
are of a simple open type; only the wealthy would have jade or porcelain cups with covers
and raised feet as opposite. The family mastif stands guard at the left.
Charles Bell

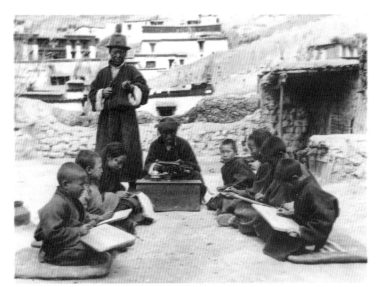

149. A school scene: a teacher and assistant with pupils who are learning to write on wooden slates covered with a white chalk. There was also reading practice, grammar, memorization of long prayers and a little arithmetic. As teachers like this man often had other full-time jobs, older pupils usually taught the younger while they were absent and an elder student would act as overall monitor. Days would start early at six o'clock in the morning and go on until about five o'clock in the afternoon, during which strict discipline was enforced. Classes ran for seven days a week, though several days were taken off in the summer for a school picnic. Children went to school at the age of about seven or eight and stayed for a few years, leaving when they were between twelve and fifteen.
Charles Bell

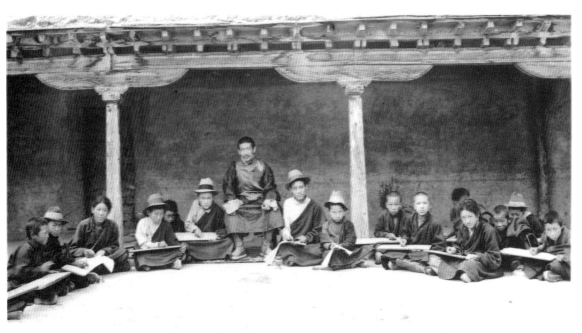

150. Novice monks being taught to write by a monk in a school at Tashilhunpo monastery. Monastic schooling was the main source of education in Tibet. Only the more advanced pupils were allowed to write on paper with ink and bamboo pens rather than on wooden boards as the beginners were. The greatest emphasis was placed on neat handwriting. The letters of the alphabet were learnt by being copied out large and then in successively decreasing size.
Charles Bell

151. Two girls play *tepe* ('big toe kick'). The object of the game is to keep the shuttlecock, made of lead with feathers fixed to it, up in the air with sideways kicks using the inside of the foot. The winner, i.e. the one who has kept the shuttlecock up the most times, could flick the knuckles of the loser with two fingers.

Charles Bell

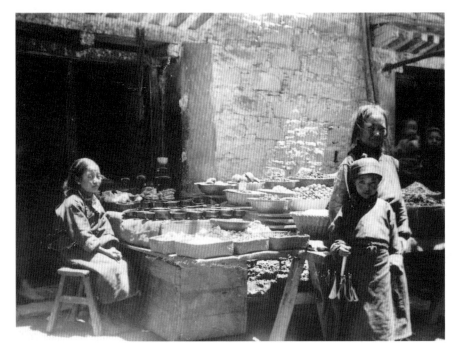

152. A shop in Lhasa with the owner's daughter looking after the outside display of fruit and vegetables. Women played a large part in the commercial life of Lhasa, where the majority of shops were kept by them. In this case the owner may have been her mother. The relatively good position of women in Tibet compared to other Asian countries was commented on by a number of western visitors. Women frequently managed their family's finances and socialized on equal terms with their menfolk, not suffering the purdah imposed in India.
Charles Bell

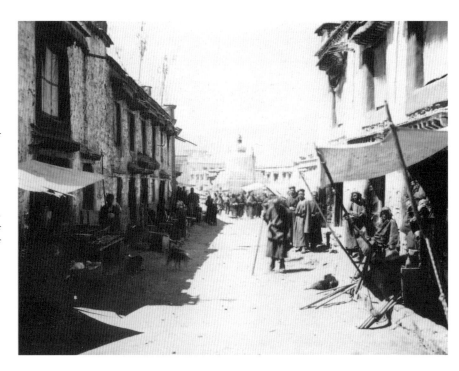

153. Though the setting up of the camera has attracted the attention of many people in this Lhasa street, making the scene look posed, one nevertheless catches something of the atmosphere. The awnings over goods displayed in front of shops are typical. At the end of the street is a *chorten*.
Charles Bell

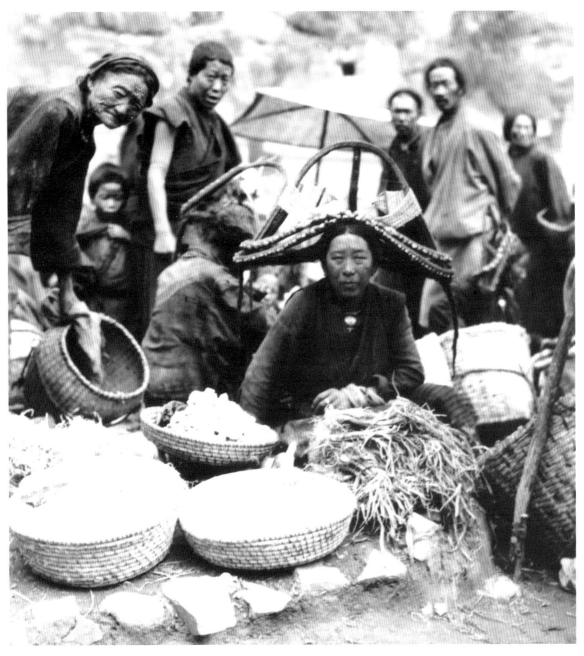

154. Women at the market held under the fort in Shigatse, selling vegetables and other produce.
Shigatse was one of the largest trading centres in Tibet. The market, open for two hours every day, sold
a wide variety of goods. The woman's head-dress, though much less elaborate than that in figure 131,
still has a few strings of pearls and a line of turquoises and corals showing she is quite well off.
Charles Bell

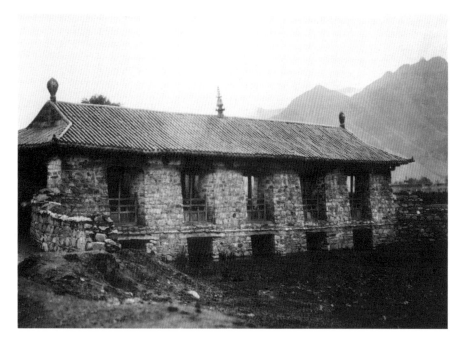

155. The turquoise bridge, an ancient structure that carried the main road to Lhasa over the river and marsh in front of the village of Sho. It was named after its greenish roof tiles added in the eighteenth century. At the corners were golden dragon heads.
John Claude White

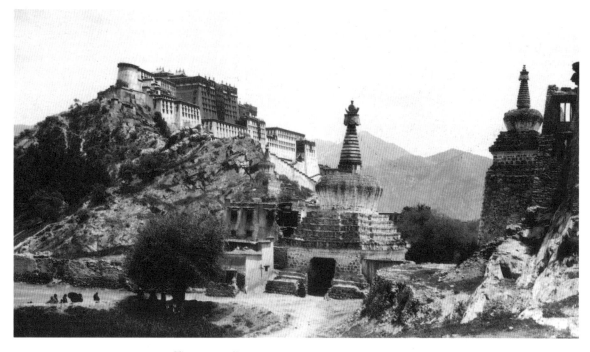

156. The west gate of Lhasa, a *chorten* gateway called Bargo Kani which the Chinese pulled down in the 1960s.
John Claude White

157. The town of Gyantse is in the foreground of this photograph and behind it is a defensively walled compound enclosing a complex of monasteries. Gyantse was a centre for wool production and had a large market which was held within the monastic area, the stalls rented out by the monks. The pyramidal form of the Kumbum can be seen rising above the other structures. The hill with its watch-towers and wall was called the 'Dragon's Back'.
Charles Bell

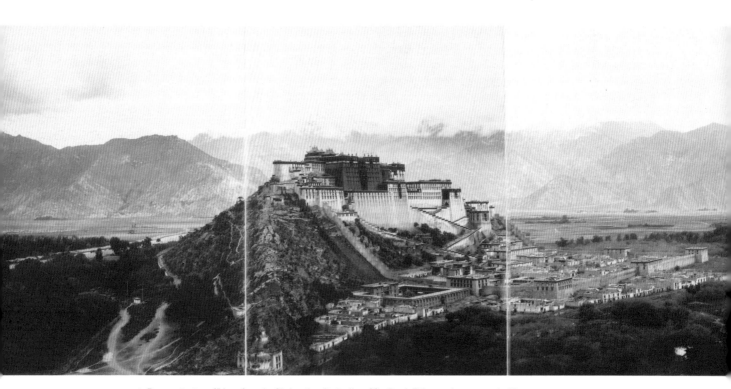

158. Panoramic view of Lhasa from the Chakpori medical college. The Potala Palace took 50 years to build (1645–94) and was the work of close to 7,000 craftsmen from all over the Himalayan region. At its foot lies the village of Sho, housing a number of government offices, courtrooms, a prison, a state printing-press, metalworkers' workshops, granaries and stables. To the left is the western gate (Bargo Kani) with part of the Lingkor or outer pilgrim route around Lhasa encircling the Potala hill. The main city lies in the right distance separated from the Potala and Sho by parks, water-meadows and willow groves.
John Claude White

Further Reading

Avedon, J., *In Exile from the Land of Snows*,
 London, 1984
Bachelor, S., *Guide to Tibet*, London, 1987
Bell, Sir C., *Tibet, Past and Present*, Oxford, 1924
— *The People of Tibet*, Oxford, 1928
 (Repr. New Delhi, 1991)
— *The Religion of Tibet*, Oxford, 1931
 (Repr. Oxford, 1968)
— *Portrait of the Dalai Lama*, London, 1946
 (Repr. London, 1987)
David-Neil, A., *With Mystics and Magicians in
 Tibet*, London, 1931
Dalai Lama, H. H. the Fourteenth, *My Land and
 My People*, New York, 1977
French, P., *Younghusband*, Glasgow, 1995
Govinda, A., *The Way of the White Clouds*,
 London, 1966
Harrer, H., *Seven Years in Tibet*, London, 1953
 (Repr. London, 1997)
— *Lost Lhasa*, New York, 1992
Hopkins, J., *The Tantric Distinction,
 An introduction to Tibetan Buddhism*,
 London, 1984

Macdonald, D., *Land of the Lama*, London, 1929
— *Twenty Years in Tibet*, London, 1932
Macgregor, J., *Tibet, A Chronicle of Exploration*,
 London, 1970
McKay, A., *Tibet and the British Raj*,
 London, 1997
Rhie, M. and R. A. F. Thurman, *Wisdom and
 Compassion, the Sacred Art of Tibet*,
 New York, 1991
Richardson, H., *Ceremonies of the Lhasa Year*,
 London, 1993
Snellgrove, D. and H. Richardson, *A Cultural
 History of Tibet*, London, 1968
Stein, R. A., *Tibetan Civilization*, London, 1972
Taring, R. D., *Daughter of Tibet*, London, 1987
Thubten Norbu and C. Turnbull, *Tibet*,
 London, 1969
Zwalf, W., *Heritage of Tibet*, London, 1981
White, J. C., *Sikkim and Bhutan*, London, 1909
 (Repr. New Delhi, 1971)

Index